**The Visual Dictionary
of Photography**

An AVA Book
Published by AVA Publishing SA
Rue des Fontenailles 16
Case Postale
1000 Lausanne 6
Switzerland
Tel: +41 786 005 109
Email: enquiries@avabooks.ch

Distributed by Thames & Hudson (ex-North America)
181a High Holborn
London WC1V 7QX
United Kingdom
Tel: +44 20 7845 5000
Fax: +44 20 7845 5055
Email: sales@thameshudson.co.uk
www.thamesandhudson.com

Distributed in the USA & Canada by:
Ingram Publisher Services Inc.
1 Ingram Blvd.
La Vergne TN 37086
USA
Tel: +1 866 400 5351
Fax: +1 800 838 1149
Email: customer.service@ingrampublisherservices.com

English Language Support Office
AVA Publishing (UK) Ltd.
Tel: +44 1903 204 455
Email: enquiries@avabooks.co.uk

ISBN 978-2-940411-04-7

10 9 8 7 6 5 4 3 2 1

Design by Gavin Ambrose
www.gavinambrose.co.uk

Production by AVA Book Production Pte. Ltd., Singapore
Tel: +65 6334 8173
Fax: +65 6259 9830
Email: production@avabooks.com.sg

All reasonable attempts have been made to trace, clear and credit the
copyright holders of the images reproduced in this book. However, if any
credits have been inadvertently omitted, the publisher will endeavour to
incorporate amendments in future editions.

Printed in China

David Präkel

The Visual Dictionary
of Photography

academia

This book is an easy-to-use reference to the key terms used in photography. Each entry comprises a brief textual definition along with an illustration or visual example of the point under discussion. Supplementary contextual information is also provided.

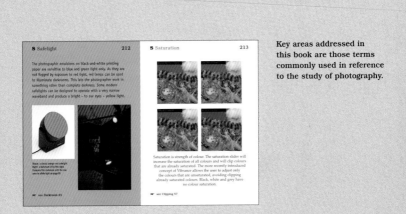

Key areas addressed in this book are those terms commonly used in reference to the study of photography.

Entries are presented in alphabetical order to provide an easy reference system.

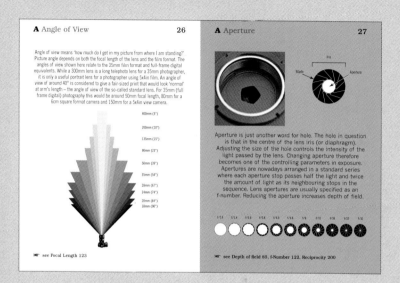

A Angle of View 26

Angle of view means 'how much do I get in my picture from where I am standing?' Picture angle depends on both the focal length of the lens and the film format. The angles of view shown here relate to the 35mm film format and full-frame digital equivalents. While a 300mm lens is a long telephoto lens for a 35mm photographer, it is only a useful portrait lens for a photographer using 5x4in film. An angle of view of around 40° is considered to give a fair-sized print that would look 'normal' at arm's length – the angle of view of the so-called standard lens. For 35mm (full frame digital) photography this would be around 50mm focal length, 80mm for a 6cm square format camera and 150mm for a 5x4in view camera.

400mm (5°)
200mm (10°)
135mm (15°)
90mm (23°)
50mm (39°)
35mm (54°)
28mm (67°)
24mm (74°)
20mm (84°)
18mm (90°)

☞ see Focal Length 123

A Aperture 27

Aperture is just another word for hole. The hole in question is that in the centre of the lens iris (or diaphragm). Adjusting the size of the hole controls the intensity of the light passed by the lens. Changing aperture therefore becomes one of the controlling parameters in exposure. Apertures are nowadays arranged in a standard series where each aperture stop passes half the light and twice the amount of light as its neighbouring stops in the sequence. Lens apertures are usually specified as an f-number. Reducing the aperture increases depth of field.

f/1.8 f/2.4 f/2.8 f/4 f/5.6 f/8 f/11 f/16 f/22 f/32

☞ see Depth of field 85, f-Number 122, Reciprocity 200

Each page contains a single entry and, where appropriate, a printer's hand symbol ☞ provides page references to other related and relevant entries.

282 283

1945–1949
Technology
First successful self-developing camera system. Model 95 is marketed by Polaroid. Zeiss Contax SLR with pentaprism for correct viewing of uncorrected image. Kodak launches Ektachrome colour reversal material.
Culture
Magnum photo agency founded by Henri Cartier-Bresson, David Seymour and Robert Capa. W. Eugene Smith's photo essay 'Country Doctor' is published in Life.

1955–1959
Technology
Plate paper copies from Halnd-Aerux stripography camera. First incident light series with dome diffuser.
Culture
Carmen Bresson's book 'Images à la Sauvette (Images on the Run)' is published in English translation as 'The Decisive Moment'.

1960–1964
Technology
Asahi introduced Nikon F introduced. Arista contrast (RC) papers introduced. First zoom lens for amateur SLR cameras introduced on Voigtländer Zoomaretic.
Culture
Minor White founds Aperture magazine. Steichen curates 'Family of Man' at MoMA, NY. Robert Frank's 'The Americans' published in US with essay by Jack Kerouac.

1980–1984
Technology
First colour 'instant' film (Polacolor) sold by Polaroid. Kodak launches Instamatic cassette loading camera. Cibachrome 'prints from slides' process introduced.
Culture
John Szarkowski curates 'The Photographer's Eye' at MoMA, NY. Andy Warhol sets up 'The Factory. David Bailey, Brian Duffy and Terence Donovan become celebrities in their own right as fashion photographers to the swinging London scene.

1965–1969
Technology
First colour photocopier (CD) pioneered at Xerox. Bell Labs' founts of digital photography.
Culture
Nathan Lyons curates 'Towards a Social Landscape' featuring work by Bruce Davidson, Lee Friedlander, Garry Winogrand and Duane Michals. Cornell Capa founds International Fund for Concerned Photography. Images begin to define the era, such as the Kennedy assassinations, and the moon landing. Eddie Adams's image of street execution of Viet Cong prisoner wins the Pulitzer Prize.

1970–1974
Technology
Integral colour image transfer, the Polaroid SX-70.
Culture
Bernal and Hilla Becher show their typologies of industrial buildings in influential exhibitions with conceptual artists in Europe and the US. Posthumous exhibition of Diane Arbus's work at Venice Biennale.

A timeline helps to provide historical context for selected key moments in the development and evolution of photography.

Welcome to *The Visual Dictionary of Photography*, a book that provides clear definitions and illustrations of key terms and concepts encountered in photography, lens-based media and the wider visual arts.

This book gives straightforward explanations of some of the more confusing jargon of the digital era (such as tone mapping and colour spaces) and makes clear the real differences between often-confused terms such as DPI (dots per inch) and PPI (pixels per inch). It demystifies the language of photographic lighting and the studio in explaining terms such as 'gobo' and 'butterfly lighting' and offers a clear explanation of the relevance and techniques of the past such as sepia toning, the wet-plate collodion process and the cyanotype. The dictionary also provides clear and relevant definitions of units such as kelvin and mired.

Left: What future for photography? This picture was rendered entirely using Maxwell Render computer software.

Opposite: The photographic gaze feeds our fascination in pictures of the human face and form across all ages, characters and cultures. Portrait of Alan Rafter-Phillips, taken by Xavier Young for JRA Architects.

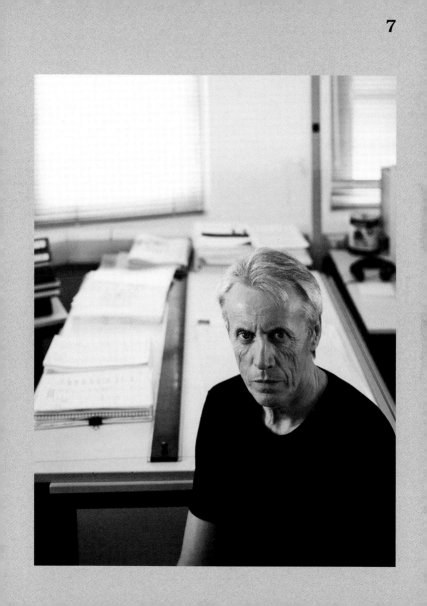

Digital photography brings computer jargon into the darkroom – images now contain metadata and require colour management in a workflow. Terms from classic optics are still relevant. Film is not overlooked.

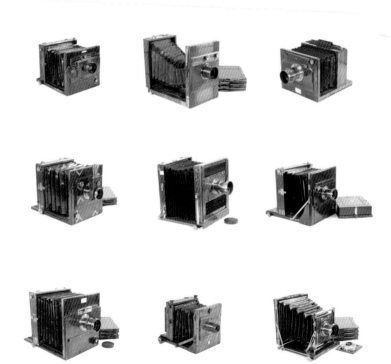

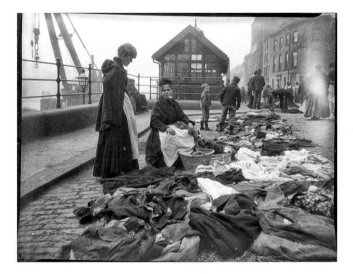

Definitions are given of lens aberrations and distortions that affect film and digital images alike. The dictionary explains the different types of film and the characteristic curve that shows how film performs under different exposure conditions and with different developers.
The book also gives lucid explanations of the different types of camera and their suitability for particular photographic tasks. The contribution made by key inventors and photographers is recognised.

Above: Photographs provide a unique window into the past, as is demonstrated by this image of the quayside in Newcastle-upon-Tyne, UK, pictured at the turn of the twentieth century. This modern digital scan was taken from the original sheet film negative.

Facing page: The inevitable success of early photography lead to a profusion of cameras, many of which survive as objects of aesthetic merit in their own right.

The timeline (pages 274–285) shows how technical innovation created the possibility of duplication and publication of images – the foundation of today's image-based society. It shows how changes in imaging technology have continually influenced the artistic community.

The dictionary stresses a belief in the importance of crossing over techniques and influences between the old and new, film and digital imaging. It is hoped that the dictionary will not only serve to explain terms and words as they are encountered but also act as a source of inspiration in itself, encouraging exploration through understanding.

Having a clear understanding of some of the complex terminology of the digital age, of historic photographic processes, styles or artistic movements will help you not only understand what you read and see. It will also enable you to think clearly and contextually and communicate your own ideas with greater accuracy and conviction.

Facing page: Skilful application of photographic technique, such as the long exposure and camera movement demonstrated in this image of near and distant forms in the Australian landscape, can still produce unique and novel imagery in a classic photographic genre.

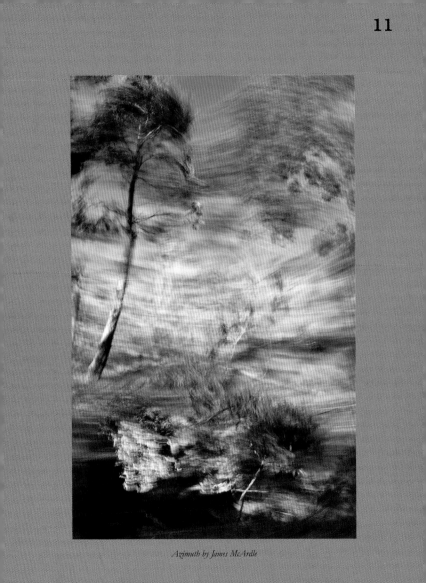

Azimuth by James McArdle

Contents

The Dictionary

Realistic abstractions are real-world objects and locations photographically represented in a novel way. The source of the image (in this case a blue plastic beach sledge, part filled with sand) is often unrecognisable.

A photograph can be described as abstract if it is in some way abstracted – extracted or removed – from reality. (There is a philosophical argument that all photography is a process of abstraction.) Two forms of abstract photography are recognised: non-representational and realistic abstractions (as shown here). Non-representational images include those reliant on only colour or geometry; these may not even involve the use of lenses and could be the result of direct manipulation of the photographic medium (such as a photogram or chemigram).

☞ see Photogram 185

Acutance is best described as how well the photographic medium handles edge contrast. High acutance gives crisp, clean edges with high edge contrast so they stand out clearly. Low acutance gives fuzzy edges that are less distinct. Film acutance is changed by development; there are high-acutance developers available. In the digital domain, sharpening increases acutance.

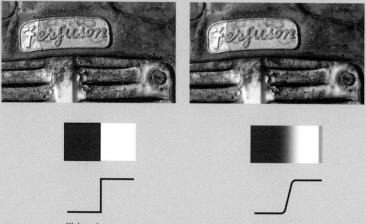

High acutance **Low acutance**

High acutance seems to emphasise detail though the image has no more resolution (real detail) than a low acutance image. The two images here are the same resolution; one with high acutance and one with low acutance.

☞ see **Sharpening 219, Unsharp Masking 259**

Adams was born in San Francisco, in 1902. His childhood love of nature never left him, although his career was originally marked out as a pianist. Photography gave a much needed structure and discipline to his life and he enjoyed success with his images of the High Sierras. Adams met and was influenced by Paul Strand and Edward Weston, forming the highly influential Group f/64 with Weston in 1932. Adams's technical mastery was legendary. He systematised a method to use the science of sensitometry (the study and measurement of light-sensitive materials) in the service of creative, expressive photography (visualisation) and the Zone System. Adams was consultant to the Polaroid Corporation and an ardent conservationist. He died in 1984.

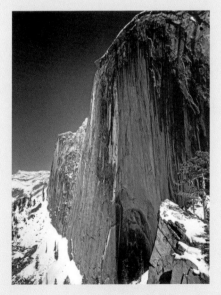

Monolith, the Face of Half Dome, Yosemite National Park, California, 1927.

☞ see Zone System 270

White light passing through a prism creates all the colours
of the rainbow but only three colours are necessary to make
up all the others. These are called the additive primary
colours (red, green and blue). Equal quantities of red, green
and blue (RGB) light always make a neutral tone: white if
they are bright enough; black if they are all absent. RGB is
the additive world of light; of photography, video, television
and computer screens.

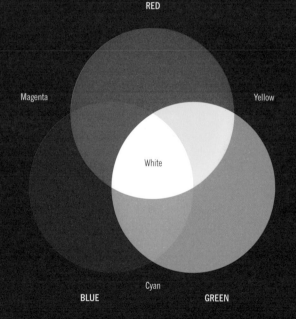

see Subtractive Colour 241

Mist and fog emphasise the effect, as seen in this image of a temperature inversion in the English Lake District.

Aerial perspective is where the distant view is seen as lighter toned through the depths of the atmosphere, while foreground shapes are seen as much darker. Chinese artists used this technique to build depth into their images.

Albumen printing-out paper was used extensively from 1850 to the beginning of the twentieth century. With albumen prints, the photosensitive material is carried in and bonded to the paper using albumen (egg white). Glass negatives were put in contact with the paper and exposed to the sun. The prints did not need to be developed but were often toned, some in gold toner, for longevity.

Albumen prints are relatively easy to identify as many show tiny surface cracks and a tendency for the albumen to turn yellow-brown, giving yellow highlights. Both features are visible in this cabinet print from 1883 taken by photographer T Tufnell Thompson of the Sergeants and Colour Sergeants of the 2nd Volunteer Battalion of the York and Lancaster Regiment, who attended annual camp that year in Blackpool. The picture includes the author's great grandfather.

Digital systems store information about the original image as a code. When a display or printer interprets that code to create an image we are seeing an alias. If the sampling process is not sufficiently good – if it does not produce enough samples – we see a distortion of the original. In the world of signal processing, this is called aliasing. Techniques to overcome poor digitisation are known as anti-aliasing. This can involve adding false data; using grey pixels of varying shades around the image edges to smooth out the steps (jaggies) produced by the sampling process. Anti-aliasing is used to achieve a smooth selection edge when selecting a range of colour pixels in Photoshop.

Vector
Smooth line and detail of original vector (mathematically described) image.

Alias
Aliasing in sampled image. The staircase lines are referred to as 'jaggies' and are the inevitable outcome of producing a raster image (sampled across a regular grid) from a vector image.

Anti-alias
Anti-aliasing minimises the effect of sampling and smoothes out the jaggies using shaded pixels to smudge the outline.

☞ see Artefacts 31, Moiré Pattern 165

The major photographic processes are the common film and digital imaging methods in use today – colour negative and reversal, black-and-white film and digital photography – many involving imaging based on silver halide chemistry. The description 'alternative processes' covers historical or commercially abandoned ways of creating imagery used by artists and photographers or hobbyists today. Many involve chemical processes other than silver halide. Some, like Vandyke brown, use the chemistry of iron salts; casein pigment prints use coloured pigments and the fats from milk; while another process sticks coloured oils to gum dichromate hardened by light. The alternative processes that do involve silver halide are usually revivals of earlier techniques such as salt paper negatives and direct positive images (ambrotypes). Many of the processes also involve contact printing from large negatives or glass plate negatives, primitive cameras (pinholes) or simple lenses.

Note: some of the chemicals involved are highly dangerous and are becoming harder to source.

☛ see Collodion Process 58, Cyanotype 80, Daguerreotype 81

Angle of view means 'how much do I get in my picture from where I am standing?'
Picture angle depends on both the focal length of the lens and the film format. The
angles of view shown here relate to the 35mm film format and full-frame digital
equivalents. While a 300mm lens is a long telephoto lens for a 35mm photographer,
it is only a useful portrait lens for a photographer using 5x4in film. An angle of
view of around 40° is considered to give a fair-sized print that would look 'normal'
at arm's length – the angle of view of the so-called standard lens. For 35mm (full
frame digital) photography this would be around 50mm focal length, 80mm for a
6cm square format camera and 150mm for a 5x4in view camera.

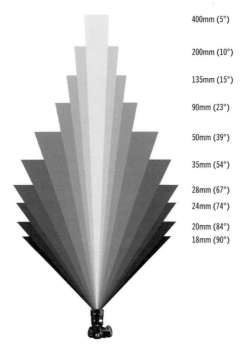

400mm (5°)

200mm (10°)

135mm (15°)

90mm (23°)

50mm (39°)

35mm (54°)

28mm (67°)
24mm (74°)

20mm (84°)
18mm (90°)

☞ see Focal Length 123

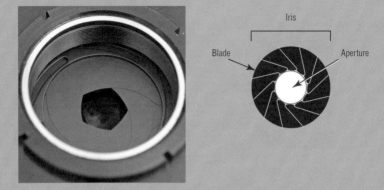

Aperture is just another word for hole. The hole in question
is that in the centre of the lens iris (or diaphragm).
Adjusting the size of the hole controls the intensity of the
light passed by the lens. Changing aperture therefore
becomes one of the controlling parameters in exposure.
Apertures are nowadays arranged in a standard series
where each aperture stop passes half the light and twice
the amount of light as its neighbouring stops in the
sequence. Lens apertures are usually specified as an
f-number. Reducing the aperture increases depth of field.

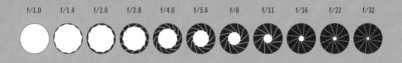

☞ see **Depth of Field 85, f-Number 122, Reciprocity 200**

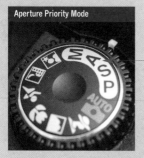

Aperture Priority Mode

The mode is marked A (aperture) or AV (aperture value) on the camera mode dial or menu. Aperture priority is ideal for portraiture or some garden photography, when a wide aperture is chosen to keep the background out of sharp focus.

Aperture priority is a semi-automatic exposure mode. It allows the photographer to choose an aperture while the camera automatically chooses a matching shutter speed to produce a good exposure.

☞ see Auto Exposure 34, Shutter Priority 223

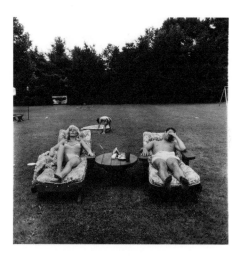

A Family on the Lawn one Sunday in Westchester, New York, 1968.

Born Nemerov in New York in 1923, Diane Arbus married young. She joined her husband Allan Arbus in a fashion photography business, working largely as stylist/artistic director. They separated in 1959. Her first published work for *Esquire* magazine (1960) showed her growing interest in exploring and documenting the characters that inhabit the fringes of society. Her photography of the strangeness of life on the periphery is as direct as the unflinching stare of a child and was first shown at the Museum of Modern Art, New York, in 1967. Depressed, she took her own life in 1971. Her status as a cult photographer of eccentric characters, sometimes depicting sexual tension, was based on the retrospective exhibition of her work in 1972. The expanded catalogue, published by Aperture, has never since been out of print and is possibly the best-selling photography monograph. Her work, sometimes criticised as harsh or exploitative, gets its power from the genuine rapport Arbus had with the people she photographed.

While archival may literally mean 'kept in an archive', for the photographer it refers to the longevity or their prints and images. Traditional photographers are concerned with chemical fading and light fading. Black-and-white films and prints seem to be most resistant to ageing, given quality fibre-based silver gelatin prints archivally washed to remove fixer (hypo). Being dye-based, most colour film and prints will be subject to fading. Dark storage in chemically inert materials at reduced temperatures will slow the process.

Digital files are subject to copying errors, loss or simple obsolescence of the storage medium where the files exist but can no longer be accessed. Digital inkjet prints now have much improved resistance to fading due to atmospheric contaminants (usually ozone) and are much more light-fast. Wilhelm Imaging Research is the first-call source for information on the stability and preservation of traditional and digital colour images.

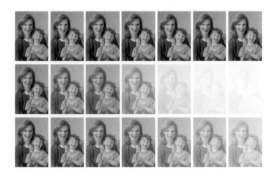

Pictured are accelerated ageing tests on inkjet prints comparing original and third-party inks (shown on the bottom two rows).

Progression (left to right) shows original prints, three and six months, one, five, ten and 25 years.

☞ see Inkjet 143, Silver Gelatin 227, Toning 253

Artefacts are unwanted effects created by some photographic processes. Compression and sharpening may produce artefacts. Sharpening is achieved by increasing local edge contrast. Carry this too far and a ghost black line will appear on one side of the edge and a white line on the other – the classic appearance of over-sharpening. The JPEG file format relies on lossy compression and, if this process is carried out too much for subsequent enlargement, *JPEG artefacts* become visible. These include areas of flat colour or banding, destruction of true detail and a tiling effect based on the averaging of pixel data in regular blocks.

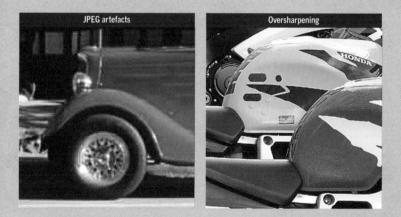

JPEG artefacts

Oversharpening

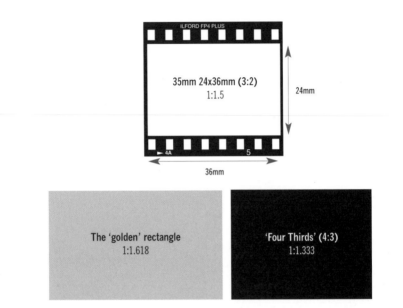

The aspect ratio of an image is its width divided by its height. This is usually given as two whole numbers. The 35mm film frame is 36mm wide and 24mm high and therefore has an aspect ratio of 3:2.

The aspect ratio of many compact digital cameras, and that adopted by Olympus, Panasonic and Kodak as an alternative to the traditional aspect ratio of film, is 4:3; hence it is called the Four Thirds system. While it is true that people prefer the proportions of rectangles based on the Golden Ratio (1:1.618) when the rectangles are empty, this does not necessarily hold true for images created in these proportions. The aspect ratios of 6x9cm (2¼ by 3½ in) format, of digital SLRs and of 35mm film come closest to the supposed ideal aspect ratio.

☞ see Format 127

Born in Libourbe, France, in 1857, Atget settled in Paris in 1890. He began photographing its streets and people, supplying images to fellow artists whose practice was to paint from photographs. American photographer Berenice Abbott, working in Paris as assistant to Man Ray, met Atget shortly before his death in 1927. She bought a large number of negatives and prints from his estate, conserving, reprinting the images and publicising the work that had gone largely unnoticed during Atget's own lifetime. Atget's photography finally received due recognition in 1968 in an exhibition at New York's Museum of Modern Art.

Street Musicians: The Organ Grinder (Joueur d'orgue) 1899–1900.

A Auto Exposure

Auto Exposure Mode

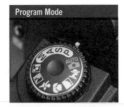

Program Mode

Both Program and Auto Exposure modes set shutter speed and aperture automatically; Auto mode will also use the built-in camera flash in low light situations in preference to a long shutter speed or wide aperture.

A camera light meter can automatically set both shutter speed and aperture (sometimes also sensitivity). In Program mode (marked P on the camera mode dial or menu), the camera will apportion available light between shutter speed and aperture according to various programmed rules. If a telephoto lens is fitted – or a zoom lens zoomed to telephoto – this mode will try to prevent camera shake by choosing a fast shutter speed at the expense of aperture. Full auto exposure (Auto) will add camera flash. These modes are ideal for snapshots or quick pictures when travelling. It may not be the best possible exposure but you will get a picture.

☞ see Aperture Priority 28, Shutter Priority 223

Camera autofocus (AF) systems rely on sensors to establish and maintain sharp focus. These sensors may be used singly or in an array of up to 50 or more. Early AF systems used active ultrasonic or infrared measurement. Modern AF systems are passive and use either image phase detection, contrast measurement sensors or a combination of the two. The system can either acquire focus once or track the subject continuously once focus has been established.

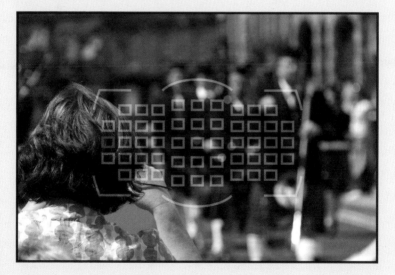

Pictured here is a representation of the viewfinder using the Nikon 51-point AF system showing one user-selected sensor in Single-point AF mode.

Available light is commonly associated with photography in low-light conditions. It is, however, any natural or artificial light that can be used by the photographer to get an exposure. The real distinction is that it is not photographic light – i.e. light that is added specifically by the photographer using flash or continuous light sources other than those already present in the scene. Available light is what some people refer to as 'ambient' light. A good idea is to think of available light as 'found' light. It then becomes the job of the photographer to exploit both its quantity and quality.

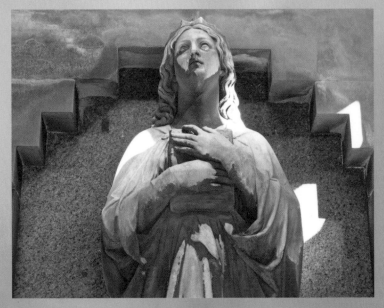

The extraordinary light in this image is internally reflected from the inner stone surfaces of Houldsworth Mausoleum (located in the Glasgow Necroplois) on to the stone statue by a single, bright sunlit opening to the upper right. Image captured with a Canon PowerShot G9 at 18.9mm, 1/25 sec at f/3.5, ISO 100.

Backlighting is light that comes from behind the subject towards the camera, creating a rim of light around the subject. Some may be reflected or spill forwards to reveal additional detail that prevents the image from being a simple silhouette. Backlighting can be difficult to meter and can produce lens flare. Outdoors it is sometimes referred to as *contre jour* – French for 'against the light'.

☞ see Flare 119, Front Lighting 131, Rim Lighting 207, Side Lighting 225, Three-quarter Lighting 246

Left: Portrait of Oskar Barnack (1879–1936).
Below: Oskar Barnack's Eisenmarkt, 1914.
Bottom: Oskar Barnack's Flood, Langgasse, 1920.

In 1911 Oskar Barnack was head of development for the Leitz optical company in Wetzlar, Germany, when he began work on a miniature hand-held camera that used perforated 35mm movie film. His idea –'small negative, big enlargement' – led him to double the movie film format to 24x36mm, the dimensions still used today. World War I intervened in its commercial development, but by 1924 the camera entered its first series production of 1000 units as the Leica (from Leitz Camera). The high-quality, hand-held viewfinder camera, which revolutionised photography, was adopted by leading photographers and photojournalists. Miniature cameras (both film and digital) with a direct link to the Ur Leica (original Leica) are still made today.

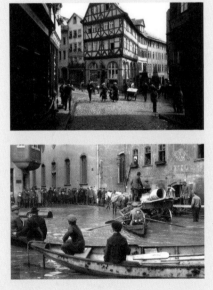

Barn doors are the four, hinged metal, matt-black painted flaps on tungsten lamps and flash heads. They are used to minimise unwanted light spills at the light source. Angling the barn doors allows the photographer to control where light falls. Barn doors create either a hard- or soft-edged shadow, depending on the distance of the lamp from the subject.

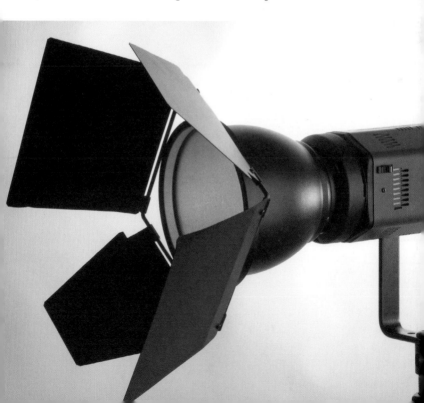

Although bellows form the camera body of a view camera – rather than a metal or plastic box – the word usually refers to a dedicated piece of equipment for close-up and macro photography. Separating the lens and camera increases magnification; a dedicated set of bellows gives flexible, intermediate levels of magnification as opposed to the fixed reproduction ratios of extension rings or tubes. Some bellows retain communication between the lens and the modern electronic camera body (auto bellows) but many do not, which means stop-down metering must be used. Some bellows offer swing and tilt to change the plane of focus or shift to crop images (useful if a slide copier attachment is fitted).

Reproduction ratios for various lenses are marked on the bed of the Canon Auto Bellows pictured here.

☞ see Extension Tubes 112, Macro Photography 157

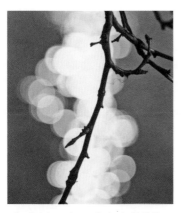

Good bokeh seen in smooth, circular highlights
from Leica prime lens.

Clear shape of seven-bladed iris visible in
highlights from zoom lens.

BOKEH (PRONOUNCED BOW-KAY) IS DERIVED FROM
THE JAPANESE WORD FOR 'BLURRED'. IT REFERS TO THE
QUALITY OF THE OUT-OF-FOCUS PORTIONS OF AN
IMAGE AND IS USED OF LENSES, WHICH ARE SAID TO
HAVE GOOD OR POOR BOKEH. JAPANESE ENTHUSIASTS
INTRODUCED THE TERM INTO MAINSTREAM
PHOTOGRAPHY IN ABOUT 2000. SOFT, CIRCULAR, OUT-
OF-FOCUS HIGHLIGHTS (SHOWN LEFT) ARE DUE TO
WELL-DESIGNED LENS DIAPHRAGMS THAT PRODUCE A
NEAR-CIRCULAR APERTURE AT ALL SETTINGS. LENSES
THAT PRODUCE HARSH GEOMETRIC HIGHLIGHTS
(SHOWN RIGHT) DO NOT EXHIBIT GOOD BOKEH.
GOOD BOKEH IS ESPECIALLY IMPORTANT IN LENSES
USED FOR PORTRAITURE.

☞ see Aperture 27, Circle of Confusion 56

B Bracketing

Bracketing is intentional over- and underexposure from the indicated exposure, usually done in whole or half stops. When the best exposure may not be that indicated by the light meter, bracketing gives the photographer a choice of images. With transparencies, for example, an ideal exposure for book or magazine reproduction was not always the same as for projection, but bracketing could produce both master shots. Modern cameras can be set to take burst sequences, putting the metered exposure first, followed by under-then overexposed images or any chosen order with three, five or seven exposures in half, whole or third stops.

Pictured is a five-image sequence at 1-stop intervals centred on the metered exposure.

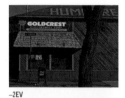

−2EV

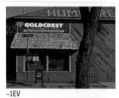

−1EV

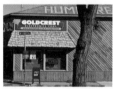

Metered

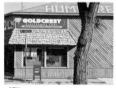

+1EV

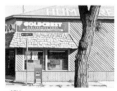

+2EV

☞ see Stop 239

Turning the head to one side makes one aspect of the face appear wider than the other, referred to as the broad and short, or narrow, sides of the face respectively. These are also the names given to the two types of three-quarter lighting: broad lighting and short lighting. With broad lighting the key light illuminates the side of the face turned toward the camera; with short lighting the main light is on the side of the face turned away from the camera. These two types of lighting are often used to change the look of the width of the sitter's face. A thin face is made to look wider with broad lighting.

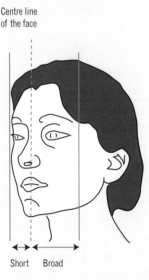

Centre line
of the face

Short Broad

☞ see Key Light 149, Rembrandt Lighting 205, Three-quarter Lighting 246

B is for bulb – quite literally as the B setting on the shutter speed dial does stand for bulb. The bulb in question is like the one pictured, on a long pneumatic shutter release. With the camera on the B setting and a bulb (or in fact any other cable release) connected, you can open the shutter by squeezing the bulb. As long as you keep squeezing, the shutter stays open. The B setting is useful for taking long exposures in low light or for subjects such as fireworks. This is sometimes referred to as Open shutter as the film or digital sensor integrates the light, sometimes movement, during the period the shutter stays open.

The T setting is related – this stands for Time. The shutter opens on the first press and closes on the second. This is more commonly a feature of large-format lenses.

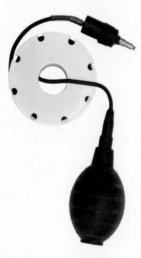

 see Time Exposure 249

The highlighted area demonstrates the fall of a butterfly shadow.

Butterfly lighting is that which falls near to and above the camera; high frontal key and fill lights that look almost like summer sunshine. Light from this direction casts a strong butterfly-shaped shadow beneath the nose of the subject on their top lip. This is then often moderated with a second, softer fill light lower than the main light. This lighting is sometimes referred to as Paramount lighting after the Paramount movie studios, which adopted this style of lighting for promotional pictures of its glamorous movie stars. Butterfly light works best with the female face; if the hair is short, care has to be taken not to light the tips of the ears unnaturally.

☞ see Fill Light 114, Key Light 149

Calibration is the adjustment of a device or mechanism so it conforms to a known standard. Computer monitors are calibrated for their colour temperature white point, contrast (gamma) and black-and-white luminance. The targets shown here can be used to calibrate scanners and cameras and include a Kodak IT-8 target for scanners (a transmission version for film is also available), the universal Macbeth Color Checker and an inexpensive colour separation card from a high-street photographic retailer. All feature some known range of colour and density patches. A photograph or scan of one of these cards can be compared with known published values for the colours or densities and the camera or scanner – usually in software – to correct for any measured errors. The data file describing the performance of the camera or scanner is known as a profile.

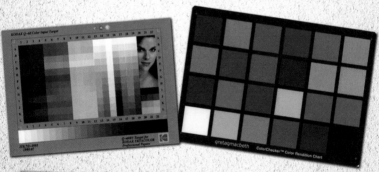

Top left: Kodak IT-8 target. Top right: Macbeth Colour Checker. Left: Jessops-branded combined colour separation scale, resolution and density card (not to same scale).

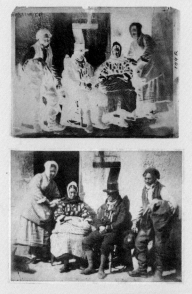

Fishwives and Fishes waxed calotype negative and salt print positive by important
Scottish photographic pioneers Hill and Adamson.

The calotype is sometimes referred to as a Talbotype after its inventor
William Henry Fox Talbot. Fox Talbot experimented with a range of
photographic processes but the calotype – a negative on iodised, high-
quality writing paper, contact printed to a salt print positive – was
refined and patented by him. The importance of the process was that
the in-camera negative could generate a number of positive prints. Fox
Talbot published the first book illustrated with original photographs –
The Pencil of Nature – in six parts between 1844 and 1846.

☞ see Negative/Positive 171

Camera comes from the Latin phrase 'camera obscura',
which translates simply as 'darkened room' or 'chamber'.
It was known and recorded as early as the eleventh century that
a pinhole in the covering of a window of a darkened room could
produce a dim, inverted image on the opposite wall. Lenses
produce a brighter image capable of being focused and the
artist's portable camera obscura was the basis for experiments
in early photography and the basis of the modern camera.
All cameras are just light-proof boxes containing light-sensitive
material; they have a lens or pinhole to project an image on
to that material and a mechanism to control the intensity and
duration of the light that enters.

An example of an early
camera obscura.

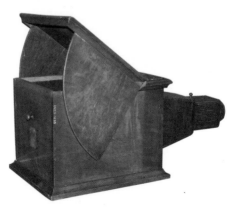

☞ See Pinhole Photography 191

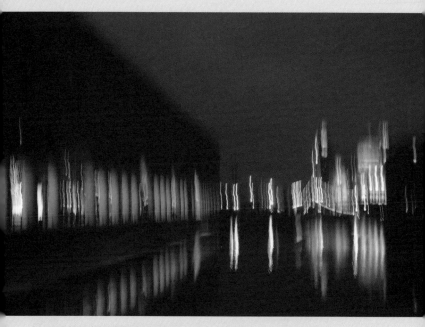

Camera shake can be used intentionally, as shown here, to impart a vertical blur to a night scene in Liverpool's Albert Dock, blurring detail but creating atmosphere.

Camera shake is one of the causes of blurred images and usually results from a poorly supported camera and a long exposure with a slow shutter speed.

☞ see Monopod 167, Tripod 254

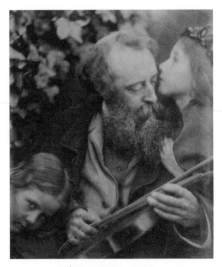

Whisper of the Muse (1865).

Cameron's short photographic career, covering just over a decade towards the end of her life (1815–1879), has been hugely influential. She moved in a circle of writers and artists, buying her home next to the estate of the poet laureate Alfred Lord Tennyson, but did not acquire a camera until her 48th birthday. In her photography, she sought to express the beautiful and spiritual. Unencumbered by photographic traditions, Cameron's strikingly intense portraits and staged allegorical images – strongly influenced by the Pre-Raphaelites – were successful, despite her occasional disregard for focus and motion blur through long exposures. See also her portrait of Sir John Herschel on page 186. Her home on the Isle of Wight, Dimbola Lodge, is now a photographic centre and can be visited today.

Cartier-Bresson's name will forever be associated with the photographic idea of the 'decisive moment'. The phrase, however, came from his American publishers; an improvement of the literal French translation of *Images à la sauvette* as 'Images on the run' for his 1952 portfolio. There is only one moment when all the elements of composition come together – the 'decisive moment'. Born in France in 1908 and considered by many the founding father of street photography and photojournalism (one of the founders of the famous Magnum photo agency), Cartier-Bresson would probably be as happy to be recalled as a painter and artist. He was an early adopter of the Leica 35mm camera and strongly disliked publicity. He did little of his own printing, composing in the camera and having photographs printed, uncropped, with a distinctive black border showing the limits of the framed image. He died in 2004.

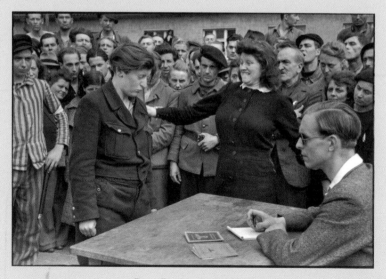

Dessau: Exposing a Gestapo Informer.

The catchlight is the bright reflection in the eyes of the subject in a portrait. Without this distinctive reflection the face can look 'unoccupied' and the sitter appears listless and disengaged. The catchlight is a reflection of the lamps used to light the portrait. The sitter's eyes may show a distinctive, circular, doughnut-shaped reflection if a ring-flash has been used; a soft box could cause a rectangular reflection to appear. Flash umbrellas are easy to spot.

In this classic Victorian studio portrait, the catchlight has been removed digitally to show this effect.

Catchlights are the reflection of the illuminating light source seen top left in each eye.

With no catchlights, the eyes — as does indeed the face — seem empty and vacant.

☞ see Ring Flash 208, Soft Box 231, Umbrella 258

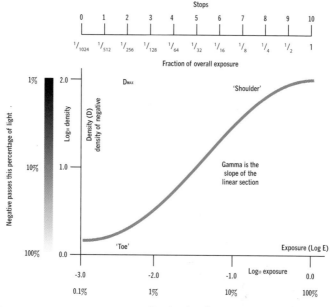

These are sometimes called H&D curves after the scientists (Hurter and Driffield) who first published them. A characteristic curve is a graph of the image density produced in a photosensitive material plotted against the logarithmic value of the exposure (which gives them their other name of D/logE curves). The slope and shape of the graph tells photographers about the contrast of the material, its tonal qualities and its handling of highlights and shadows. The slope of the curve is given the Greek letter gamma. A steep central portion means high contrast; a gentle slope means low contrast.

Chromatic aberration (CA) is a lens fault that occurs when the lens cannot focus different colours at the same spot. There are two types: longitudinal and lateral. The bending power of a lens (refractive index [RI]) varies with the colour (wavelength) of the light. Blues are brought to focus before longer wavelength reds behind the lens. To correct this longitudinal CA, lens pairs made of different glass with different RIs are used. These are called achromatic elements and, depending on the quality of the lens, correct for two colours (an achromatic lens) or three colours (an apochromatic lens). Lateral CA is seen as colour fringes at the edges of an image, as shown in this magnified example from a zoom lens. It can be corrected to some extent by computer software; some cameras now offer in-camera CA correction with that manufacturer's lenses.

Chromatic aberration can be seen here as green fringing to the left of the image, red fringing to the right.

At small enlargements, chromatic aberration may not be notice-able but enlarging the portion of the treeline from the middle left of the main image (inset detail) shows the effect clearly.

This image shows a popular brand of 35mm chromogenic film with the black-and-white negatives produced from colour development (some films do not have the orange mask shown here). The exhibition print is one made from a chromogenic negative.

Chromogenic simply means 'made from colour'. Chromogenic black-and-white film produces black-and-white negatives but is processed in colour film chemistry at any mini-lab (C-41 process). The film is virtually grain-free, with a velvety quality, attractive in portraits. The film also scans well. Wedding photographers use this film so they can process all their colour and black-and-white film at the same time. Chromogenic film can be a convenient way of working in black and white when travelling and proofs are needed without darkroom facilities. It can be an easy first step into black and white for those without a darkroom.

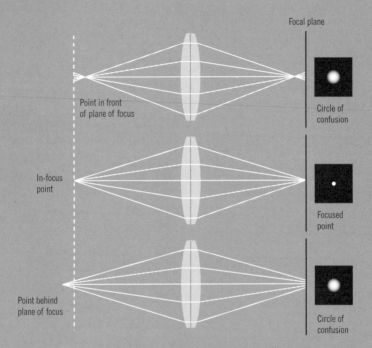

Focal plane

Point in front
of plane of focus

Circle of
confusion

In-focus
point

Focused
point

Point behind
plane of focus

Circle of
confusion

No lens can resolve an image point as a point; it produces a tiny disc of light that from a distance, to human vision, looks just like a point. This tiny disc is called the least circle of confusion. Images are created from a multitude of these tiny overlapping circles. Circles of confusion are produced when a lens is not in perfect focus and they get bigger the further away they are from correct focus. Another name is blur circle. Reducing the lens aperture makes the circles of confusion smaller, thereby increasing the apparent depth of field in the image.

☞ see Depth of Field 85

The idea of clipping comes from signal processing technology. If a sensor has a limit on the range of signals it can handle then once the limit is reached, higher or lower level signals are simply recorded at that limit. The sensor is said to 'clip' the data. In digital photography, the image sensor can only handle a certain number of light levels. Any information exceeding this range will be clipped, recorded as a maximum (highlight) or minimum (shadow) value, and information will be lost.

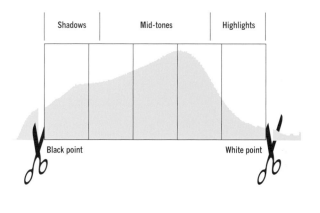

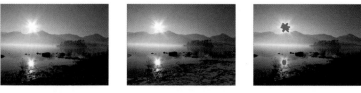

| Original image | Dark clipping | Light clipping |

☞ see Highlight 138, Histogram 139, Shadow 218

Deliberately underexposed, collodion images, backed with black or coated on black glass or metal, produce positive ambrotype images. A contemporary in-camera (mirror image) ambrotype is shown here.

Spruce Pine, North Carolina, 2008.

Paper and metal were first used as carriers for photographic emulsions. Although glass was an obvious choice, being both stable and transparent, problems came when experimenters tried to stick their emulsions to its smooth surface. In 1847, Frederick Scott Archer used a mixture of guncotton (cellulose nitrate) dissolved in a mixture of sulphuric ether and grain alcohol to coat a glass plate. This was sensitised in a bath of silver nitrate and the image was made while the plate was still wet, so as not to lose sensitivity. Collodion (from the Greek for 'glue') dries to a strong transparent film and it was used for negatives on glass. Archer did not patent his wet plate process – it was widely used for over 30 years until the advent of gelatin dry plates.

☞ see Alternative Processes 25

One of the measuring instruments used in the pursuit of colour management, the colorimeter, is an optical device used to measure the colour performance of a computer monitor. It measures the relative intensity of the red, green and blue light emitted by controlled colour samples displayed on the monitor.

The spectrophotometer is a related device that measures the amount of light reflected at each wavelength; it is most commonly used to measure colour swatches to profile a colour printer. A third device, usually only seen in advanced black-and-white darkrooms or printing works, is the densitometer. This can measure the optical density of photographic materials from the amount of light reflected or transmitted. It is used with black-and-white film and prints.

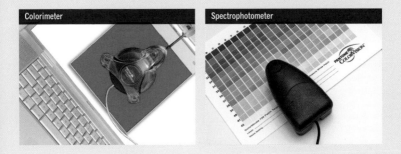

Colorimeter

Spectrophotometer

☞ see Calibration 46

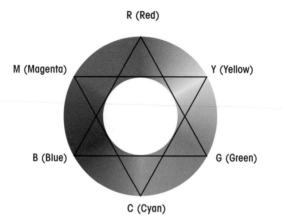

Colour is our perceptual response to different wavelengths of light energy that fall on light-sensing cells in the retina of the human eye.

Photographers place the colours of the spectrum around a wheel to help choose filters or change an image. The additive primary colours of red, green and blue are 120° apart on the wheel. All other colours are combinations of the three primaries and lie in between.

Opposite pairs across the wheel are described as complementary colours. Digital camera users will often find hue (colour) adjustments described as a certain number of degrees. This represents a shift in colour around the colour wheel through an arc of that angle. In compositional terms, colours close to each other are said to be in harmony; colours opposite on the wheel are discordant.

☛ see Complementary Colour 71

A colour cast is an unwanted, overall colour change in an image. The colour shift causing the cast can be identified from a 'ring-around', as shown here. Some ring-arounds also show the strength of the cast along a dimension moving out from the centre of the circle. A cast is corrected not by reducing its colour but by introducing the opposite or complementary colour. For instance, a blue cast is corrected by adding yellow.

R (Red)

M (Magenta)

Y (Yellow)

Neutral

B (Blue)

G (Green)

C (Cyan)

see Colour and the Colour Wheel 60, Complementary Colour 71

C Colour Conversion Filters

A comparison of the European and Wratten systems

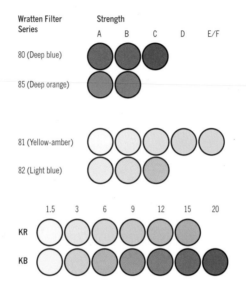

Colour conversion filters let the photographer match the colour temperature of the lighting to the film being used. They are little used with digital cameras. In Europe, the filters are described as KB (bluish) filters, which increase colour temperature, or KR (reddish) filters, which reduce it. The Wratten colour conversion filters from the deep blue 80 series and deep orange 85 series are used for making major shifts in colour temperature, allowing daylight film to be used with tungsten light, for instance (KB15 or 80A). The Wratten light-balancing 81 series filters (yellow-amber) lower the colour temperature and 82 series filters (light blue) raise the colour temperature in much smaller steps than the colour conversion filters.

☞ see Colour Temperature 70, Cool Colours 77, Tungsten 255, Warm Colours 265, Wratten Filter System 269

Colour correction or colour compensating (CC) filters are used to make changes in the overall colour balance of images and to correct colour casts. They can also be used to correct for batch variations in colour film, slight colour imbalances in studio lighting or for film reciprocity effects. Today, colour correction is more often done after scanning or capture, using image-editing software.

CC filters are usually gelatin (not glass). As the diagram shows, they are available in cyan, magenta, yellow, red, green and blue in a range of densities rated 05 and 10 to 50 in units of ten. Stacking filters together can make intermediate values. Red CC filters are still used by underwater photographers to re-balance colour.

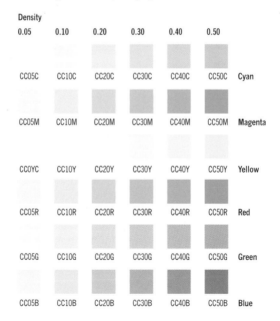

Density						
0.05	0.10	0.20	0.30	0.40	0.50	
CC05C	CC10C	CC20C	CC30C	CC40C	CC50C	Cyan
CC05M	CC10M	CC20M	CC30M	CC40M	CC50M	Magenta
CC0YC	CC10Y	CC20Y	CC30Y	CC40Y	CC50Y	Yellow
CC05R	CC10R	CC20R	CC30R	CC40R	CC50R	Red
CC05G	CC10G	CC20G	CC30G	CC40G	CC50G	Green
CC05B	CC10B	CC20B	CC30B	CC40B	CC50B	Blue

☞ see Colour Cast 61, Filter 116, Reciprocity Failure 201

Tri-linear array with strips of red, blue and green sensors.

Bayer pattern mosaic with twice as many green photo sites as red or blue.

Three-layer structure of the Foveon image sensor.

The process by which a digital image is created is known as sampling. The image is sampled at regular intervals and the value of colour found recorded in a number code. Each of these is a pixel. Light-sensitive devices can be arranged in a line and the image scanned (a row of sensors is needed for each primary colour). This is the linear array used in scanners and in early digital cameras with scanning backs. This mosaic is called a Bayer pattern, after Dr Bryce E Bayer of Eastman Kodak.

No scanning is required as the device captures the whole image at once. This is called a field array. The software that works out the finished data does a process know as de-mosaicing. The Foveon chip is the only sensor that records red, green and blue values at the same physical point in the image, having a layered structure. Foveon X3 direct-image sensors are used in Sigma cameras.

☞ see Digital Photography 91, Pixellation 192

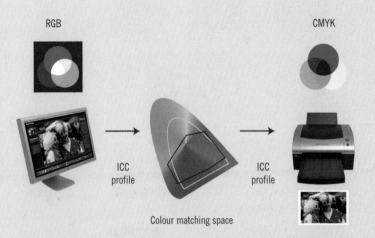

RGB

CMYK

ICC
profile

ICC
profile

Colour matching space

Colour management is the suite of computer software that attempts to match colour from input, through display to output. Colour management systems need a profile of each device (camera, screen, printer, scanner) in order to do this. The data from each device can then be modified (based on information from the profile of its colour performance) and colour adjusted so it is seen as being the same. Therefore, what you see on your camera is the same as what you see on the screen and on the print.

☞ see Colour Models 66, Colour Space 69

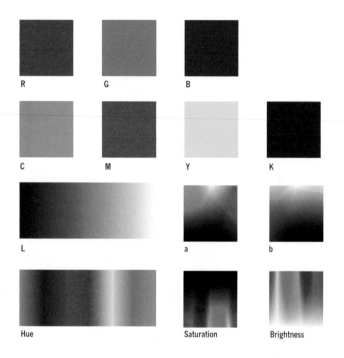

R G B

C M Y K

L a b

Hue Saturation Brightness

Colour models are a way of specifying colour numerically in terms of the mix of primary colours. Colour models include RGB (red, green, blue), CMYK (cyan, magenta, yellow, black), HSB (hue, saturation, brightness) and Lab (Lightness, a and b – dimensions of this model carry the red to greenness and blue to yellowness of the image respectively). The Lab mode is based on synthetic primaries originally described by the International Commission on Illumination (CIE) in its CIE L*a*b* model.

☞ see Additive Colour 21, Subtractive Colour 241

This is a negative film where every colour in the original scene is represented by its complementary colour to produce a positive print. The orange mask is a puzzling feature of the colour negative. Because the negative is only a means of making a finished print and not an end in itself, this mask can be used to control contrast and compensate for shortcomings in the dyes used in the colour paper. Colour negative material is processed using C-41 chemistry (or equivalent).

Left: 35mm colour negative showing distinctive orange mask.

Note the red buoy in the final image is bright blue-green on the negative – the complementary colour of the specific shade of red.

see Dynamic Range 100

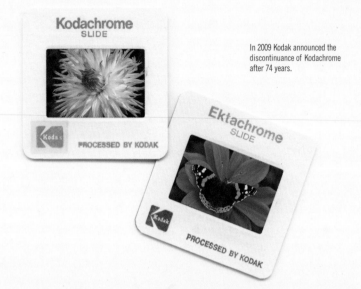

In 2009 Kodak announced the discontinuance of Kodachrome after 74 years.

Colour reversal film produces a negative image in the camera but is processed to give a final positive colour image. This material is referred to by many names including Pos (positive) film, Slide film and Transparency film ('trannies'). Finished images can be printed using a direct positive dye-destruction system such as Ilfochrome, digitally scanned for reproduction or projected for viewing. Individual images are often mounted in plastic or card mounts as 'slides'. There are two main processes. Kodachrome (introduced in 1936 for stills photography) is unique: its triple sandwich of black-and-white emulsions, sensitive to red, green and blue light, are dyed during processing to give outstanding colours and good longevity. All other modern colour films are chromogenic, with dye-couplers already in the emulsion layers. They are processed in E-6 chemistry (or equivalent).

☞ see Dye Destruction 98, Dynamic Range 100

Colour space is a three-dimensional
representation of the colours that
can be reproduced by a colour model.
Some models have the potential to
store more colours than others.

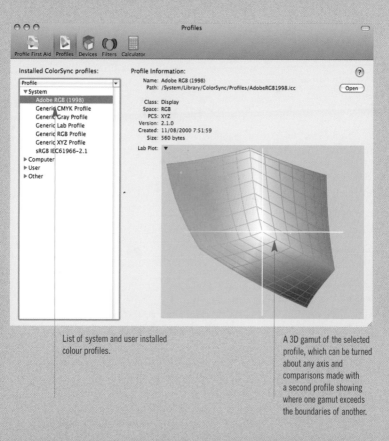

List of system and user installed
colour profiles.

A 3D gamut of the selected
profile, which can be turned
about any axis and
comparisons made with
a second profile showing
where one gamut exceeds
the boundaries of another.

C Colour Temperature

Colour temperature is based on the fact that a standardised object will give off coloured light depending on its real temperature – phrases such as 'red hot' or 'white hot' encompass the idea. A colour temperature scale is a measure of 'whiteness' of light, which is recorded in kelvin (using the symbol K, not degrees kelvin). The orange-yellow glow of candles is about 2,000K; 5,500K is photographic daylight and anything over 7,500K appears blue.

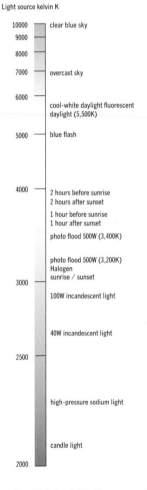

Light source kelvin K

10000	clear blue sky
9000	
8000	
7000	overcast sky
6000	cool-white daylight fluorescent daylight (5,500K)
5000	blue flash
4000	2 hours before sunrise / 2 hours after sunset
	1 hour before sunrise / 1 hour after sunset
	photo flood 500W (3,400K)
	photo flood 500W (3,200K) / Halogen / sunrise / sunset
3000	100W incandescent light
	40W incandescent light
2500	
	high-pressure sodium light
	candle light
2000	

A colour temperature meter, such as the Sekonic Prodigi C-500 (shown left), can directly measure colour temperature.

☞ see Flash 120, Fluorescent Lighting 121, Kelvin 147, Tungsten 255, White Balance 266

This image uses a composition technique based on a complementary triad of colours: two complementary colours (red and blue), with a third roughly midway between (yellow). The chrome and black provides an achromatic foil; a colourless, neutral background that sets off the colour relationship between the three primaries.

These are the colours that lie opposite each other on the colour wheel. The red-cyan, green-magenta and blue-yellow pairings are especially important in colour reproduction. When mixed, any complementary pair produces a neutral result. So in colour correction, an image with a blue cast can be corrected by adding the yellow colour that lies opposite on the colour wheel.

Photographers working in black and white choose colour filters to darken or lighten the appearance of tone from certain colours in their subjects. Filters of a complementary colour are used to darken (which is why red filters darken cyan skies).

☞ see Colour and the Colour Wheel 60

Although composition involves the formal elements of art (line, shape, form, space, texture, light and colour) and the design principles (variety, rhythm and repetition; emphasis, movement and balance) it is much more than the application of rules. Geometric rules inherited from classical compositional analysis of paintings are only of use after the fact; as a tool to analyse a finished image and not to create it. Some common compositional concepts such as Leading Lines (compositional lines that are meant to 'lead' the eye to the subject) are not really supported by modern research into eye-movement. Proportion is said to play a large role in format choice and subject placement and is often informed by Golden Number divisions (a 1:1.618 ratio).

Composition is everything that goes into creating an image. The process of image composition begins with consideration and exploration of the chosen subject. It involves selection and analysis of the subject in terms of its visual attributes, an appreciation of the subject itself and the process in light of one's personal feelings and motivations. Only then can all the elements be arranged into a coherent, communicative and unique image. Photography cannot be a simple recording because photographers have to select part of the real world to frame. Composition becomes the expression of the photographer's personality.

☞ see Rule of Thirds 210

How does composition really work? By deliberately and carefully analysing each image-making opportunity, by identifying formal elements and design principles, then weighing their importance against your own intentions, composition becomes 'implanted'; a spontaneous and unconscious part of photographic practice.

Only on the 10th exposure did 'the moment', viewpoint and picture geometry come together for the required organisation of time and space. Muted colour presentation and darkened sky were part of the pre-visualisation of the finished composition.

C Contact Print

Shown here is a paper negative photogram (top) made from a leaf and a positive contact print (bottom) made from that negative.

A contact print is a positive print made directly from the negative without enlargement. It is produced by placing the emulsion (image) side of the film in contact with the upwards-facing emulsion side of the photographic paper. This is done in a contact printing frame or under a sheet of glass to maintain a good and even contact. A high degree of detail is transferred, although the print will always be the same size as the negative. Fine-art prints can be made from digitally produced negatives printed on to acetate sheet in an inkjet printer or imagesetter.

A contact sheet is a contact print of every negative on a film printed on to a single sheet of photographic paper. It is used for filing and identification. Some film filing systems are made of see-through plastic and allow contact sheets to be made without taking the film out of the sleeves.

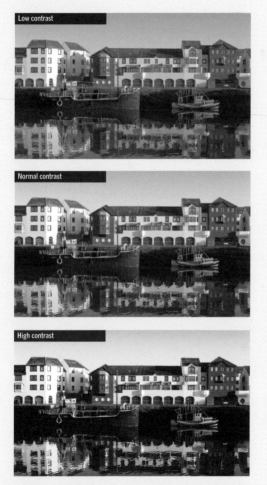

Contrast is the perceived difference between the dark and light parts of an image. It can also be thought of as the rate of change of tones from dark to light.

High-contrast images comprise mainly darker tones and light tones; low-contrast images will comprise mainly mid-tones and will not show the tonal extremes of a high-contrast image. A normal-contrast image has a regular distribution of tones from dark shadows through mid-tones to light, highlight tones.

see Variable Contrast 260

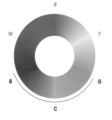

The cool colours of the Urbis building's glass façade (in Manchester, UK) were captured with a Nikon D100 Sigma 10–20mm f/4–5.6 EX DC HSM super wide angle zoom at 19mm, 1/1000 sec at f/6.7, ISO 200.

Cool colours are those in the blue and blue-green segments of the colour wheel. This is based purely on a psychological association and has nothing to do with the colour temperature scale. Cold tone photographic paper has a distinct blue-black. Cool down filters – such as the Wratten Series 82 light-balancing filters – actually raise the numeric colour temperature, but they have the effect of making the image appear less warm, hence their name.

☞ see Colour and the Colour Wheel 60, Colour Conversion Filters 62, Warm Colours 265

The Photoshop Crop toolbox icon is designed to show the traditional L-shaped pieces of black card or plastic used to find a good crop for an image (these are known as 'cropping ells'). The thin diagonal line is like the diagonal line used on the back of prints for proportional scaling.

Final crop

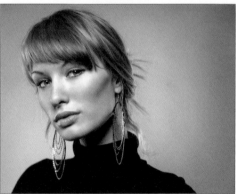

The cropping process reframes an image after it is taken. This may involve changing the aspect ratio of the image. Cropping is done to straighten up images on the skew, to emphasise detail or to improve some aspect of the composition.

Cross processing is the intentional choice to develop colour film materials using the 'wrong' chemical process. Reversal film for processing in E6 chemistry can be developed in chemistry intended for colour negative films (C·41 process). Alternatively, a colour negative film can be processed in E6 chemistry. The distinctive look has been much used in fashion photography. Cross processing can be mimicked digitally by adjusting the red, green, blue and master contrast curves.

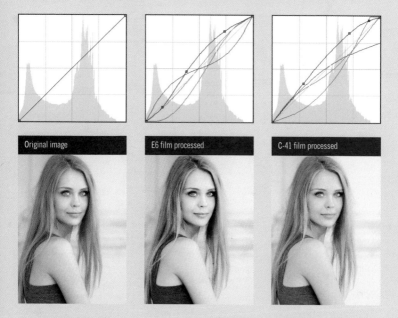

Original image E6 film processed C-41 film processed

Pictured here are the original image and versions created with Photoshop to create the look of E6 film cross-processed in C-41 chemistry and colour negative material cross-processed in E6.

☞ see Colour Negative Film 67, Colour Reversal Film 68

Rather than silver, the cyanotype relies on iron chemistry for its distinctive cyan/blue image. Discovered by Sir John Herschel in 1842, it is still popularly known as a 'sun print' or 'blueprint'. Being easily developed in water after prolonged exposure to UV light, the sun print is many people's earliest meeting with photosensitive materials in school. Cyanotypes are usually associated with photograms but they can be used with conventional negatives to produce full-toned images. The Victorian photographer Anna Atkins first used the process photographically in a series of cyanotype books documenting ferns and leaves. It is perhaps one of the easiest alternative processes to try but also one of the most difficult to perfect.

Untitled, self-portrait, 2006 (Andrew Youngman).

☞ see **Alternative Processes** 25, **Photogram** 185, **Photography** 186

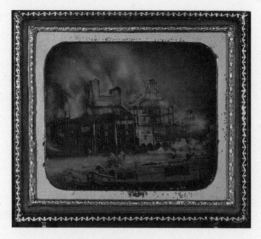

Burning Mills along the River at Oswego, New York, 1853.

Louis Jacques Mandé Daguerre is credited with perfecting the first practical photographic process involving development. The daguerreotype was a polished, silvered copper plate exposed to iodine and developed with fuming mercury to give a direct negative image. A daguerreotype only appears positive because of the silvered backing, which reflects light. Daguerre's invention was announced in 1839 in France, news of which provoked William Henry Fox Talbot to rush into announcing his process to the Royal Society in Britain. While Talbot patented his process, Daguerre was given a state pension by the French government, which announced the daguerreotype as a 'gift to the world'. Each delicate daguerreotype is a unique original and as such they were often kept behind glass in cases. The cost of materials and difficulty in reproducing the images – not to mention the poisonous chemistry – were all reasons for its eventual decline. Unusually, this image by George N Barnard is a daguerreotype copy (right-reading) that has been hand coloured.

☞ **See Calotype 47**

Ground-glass viewing screens on large-format cameras are usually dim, especially with the lens set to the taking aperture. To see any image on the screen at all, it needs to be completely shaded from ambient light. The most convenient way to do this is with a large black cloth that covers the camera and the photographer's head. The darkcloth was once the 'badge' of the photographer.

☞ see Ground-glass Screen 136

As these images show, darkrooms are laid out with all printing and enlargement done at a 'dry' end of the room (highlighted here in pink) and all wet processes done at a 'wet' end (highlighted here in blue).

The darkroom is a room dedicated to photographic processing, as many of these processes need to be conducted in complete darkness or in subdued light. A film darkroom will be completely lightproof or may have a very dim, dark-green light that can be switched on momentarily. Darkrooms for photographic printing are lit with safelights that use a wavelength of light (colour) to which black-and-white photographic paper is not sensitive. Darkrooms for colour printing are completely blacked out.

☞ see Enlargement 105, Safelight 212

D Daylight

Photographic daylight is the average summer sunlight as measured at noon on the Mall in Washington DC, USA, corresponding to a colour temperature of 5,500K. Practically speaking, that means the sun is out in a blue sky, one-third filled with fluffy white clouds. Skylight is light of a blue quality reflected from the atmosphere that, when mixed with direct sunlight and reflected light from clouds, gives photographic daylight. Daylight film is balanced to give neutral colour only in these conditions – other lighting will require filtration.

This image is clearly taken in daylight, but does it correspond to the exact photographic definition of daylight? It actually measures 5,300K. Image captured with a Canon PowerShot G9 at 12.7mm, 1/1250 sec at f/4, ISO 100.

☞ see Colour Temperature 70, Filter 116, Kelvin 147

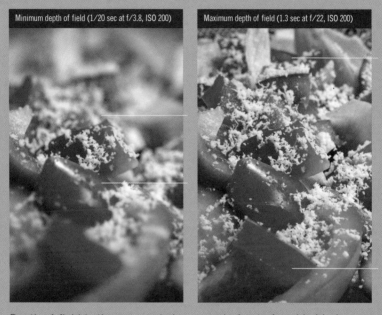

Minimum depth of field (1/20 sec at f/3.8, ISO 200)

Maximum depth of field (1.3 sec at f/22, ISO 200)

Depth of field is the apparent sharpness in front of and behind the exact point of focus. It varies primarily with aperture but is also influenced by format and focusing distance. Acceptable focus is determined by the size of the circles of confusion; reducing the aperture also reduces the size of these blur circles and makes more of the image appear to be in focus. Depth of focus is effectively depth of field inside the camera at the image plane; film that is not held flat may appear out of focus even though the lens was perfectly in focus. Some lenses feature a depth of field scale that show what range of distances will be in focus at any given aperture. The images pictured here were taken with a Nikon 60mm f/2.8D AF micro lens.

☞ see Circle of Confusion 56

Modern SLR camera viewfinders are bright because focusing and composition are done with the lens at maximum aperture. When the shutter is pressed, the aperture closes to the smaller taking aperture and the image is recorded. This arrangement means you cannot see the effect of increased depth of field from the taking aperture through the viewfinder.

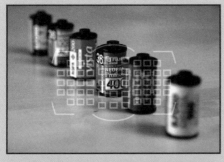

Many cameras are provided with a depth-of-field preview lever or button that lets the photographer close the lens down to the taking aperture to judge depth of field. The viewfinder becomes darker – as shown in this simulated image – but the increased sharpness in front and behind the point of focus becomes clear.

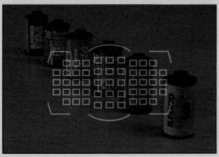

☞ see Aperture 27, Depth of Field 85

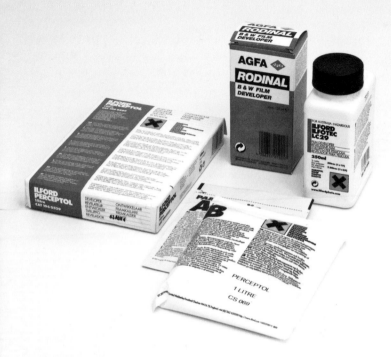

The latent (hidden or potential) image on exposed film needs to be developed – chemically amplified – to create a visible image. Developers are the various chemical agents that react with the tiny 'sensitivity specks' of metallic silver created in the film during exposure, to produce a visible silver image that is dark where light struck the film (this is a negative).

Colour images require a much more complex development process. A range of liquid concentrate and powder developers is pictured. The final contrast and graininess of film can be affected by the choice of developer; some enhance edge definition, others increase contrast.

☞ see Film 115, Negative/Positive 171, Silver Halide 228

Exposed film needs to be developed without further exposure to light. This can be done in trays in a blacked-out room. It is, however, easier to load the film into a light-proof tank or drum in the dark. Then, in normal light, developer, stop bath and fixer can be introduced into the tank through light-proof seals that allow liquids to pass. Once the film has been developed and fixed, it can be washed in daylight and removed from the tank. The one-piece funnel and lid fits into the hollow central spindle to create a light-proof container. The black plastic cap makes the whole tank waterproof, allowing it to be inverted to agitate the developer.

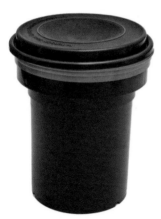

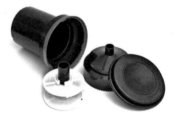

Above: film spiral on spool and light-tight funnel fit into tank beneath waterproof lid. This tank can hold two 35mm film spirals or one 120 roll film.

Left: tank loaded and ready for inversion.

☞ see Developer 87

Closing the lens aperture increases depth of field. To get maximum depth of field – and therefore the sharpest image from front to back – you would expect to stop the lens down all the way to its minimum aperture. Lenses have a 'sweet spot' aperture; anything smaller than this causes the diffraction effect, which begins to reduce resolution by increasing the size of the circles of confusion. The best analogy is to think of a hose being pinched tighter and tighter, which will spray wider and wider; instead of creating a neat, focused circle it creates a rippled diffraction pattern called an Airy disc. Sometimes the extra depth of field is worth the slightly lower resolution.

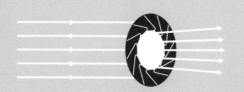

Light rays passing through any aperture begin to diverge and interfere.

Circle of confusion.

Small aperture causes significant divergence and diffraction interference.

Airy disc.

☞ see Aperture 27, Circle of Confusion 56, Depth of Field 85

There are really only two qualities of light needed to create the full range of photographic lighting effects. These come from the spotlight and the floodlight. The soft light shown here comes from the floodlight – or its modern equivalent, the soft box or diffuse light source. This is light that comes from a large area relative to the subject. It is not concentrated.

Compare this image with the entry for Point-source Lighting to see the difference. Note the soft quality to the highlights here, the lack of any real shadows and the gentle treatment of the wood texture.

☞ see Point-source Lighting 193

Steven Sasson
with the
prototype
digital
camera.

Digital photography has a longer history
than many people may realise. The first
experimental digital camera - which stored
crude, 10,000-pixel, black-and-white images
on cassette tape - was produced by Steven
Sasson, an Eastman Kodak engineer, in 1975.
Digital image processing requires an image
to be sampled at regular intervals by a
sensing device and for the data for each
picture element (pixel) sensed to be stored
in number form. Once encoded, digital images
can be copied or transmitted without loss,
compressed and enhanced or manipulated.

☞ see Colour Filter Array 64, Pixel/Pixellation 192

A single-lens element will distort the image shape
depending on whether it is in front of or behind the
aperture. The aperture behind the iris or diaphragm creates
barrel distortion – so-called because it is bloated like a
barrel. With the lens ahead of the aperture, you get
pincushion distortion – named after the pinched shape of
a dressmaker's cushion for sewing pins. These distortions
of image shape are corrected in lens design; the distortions
produced by elements ahead of the stop are offset by those
behind. In complex camera lenses, there may be some
residual distortion, while in zoom lenses the complex optics
may display different forms of distortion at each end of their
focal length range; barrel distortion is particularly
noticeable at the wide-angle end of many inexpensive
zooms. Stopping down the lens will not help.

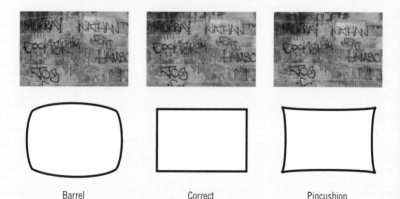

Barrel Correct Pincushion

☞ see Aperture 27

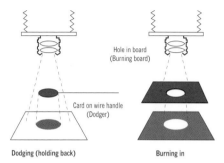

Hole in board
(Burning board)

Card on wire handle
(Dodger)

Dodging (holding back) Burning in

Dodging and burning are both forms of local area exposure control. Dodging (sometimes called holding back) makes things lighter; burning or burning-in makes them darker. The words come from darkroom usage where a board with a hole in it is called a burning board; it is used to give extra exposure to one small area, thereby darkening that part of the black-and-white print. Burning can be done through a hole between your fingers. Dodging needs something to cast a shadow to hold back exposure and make the area lighter. Most photographers shape what they need from wire and card or tin foil — known as the 'dodger'. The dodger, burning board or hand must be kept constantly on the move to give smooth tonal transitions.

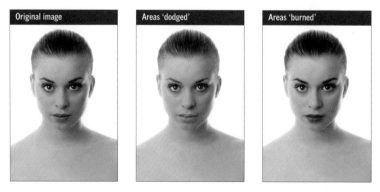

Original image | Areas 'dodged' | Areas 'burned'

Sheet film for large-format cameras is commonly loaded two sheets at a time in a double dark slide. This two-sided container has a thin, light-proof slide, like the lid of a pencil box. This can be slid open to reveal the film once the double dark slide is slipped into the spring-mounted film back on the camera. The film is exposed by tripping the shutter; it is then removed from the camera by reinserting the dark slide. The double dark slide can then be turned over for a second shot. Loading is easy in the darkroom (shown here in light), with the film emulsion-side up and slipped between rails inside the double dark slide. The dark slide itself is by convention turned white-side out for unexposed film but dark-side out for exposed film. Never open a double dark slide in daylight with a slide showing black as it may contain exposed, undeveloped film.

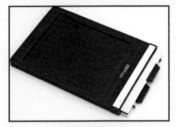

Double dark slide

Loading a dark slide

Dark slide with exposed FP4 film

Dark slide empty

☞ see Format 127, Sheet Film 220

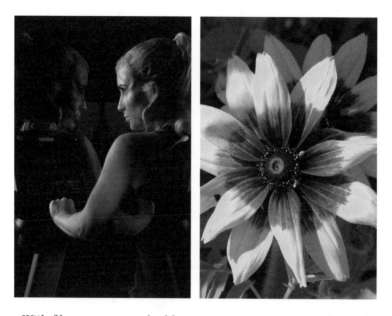

With film cameras, a double exposure was a common hazard of forgetting to wind the film on between pictures. Two or more images can be made on the same piece of film (double or multiple exposures). A subject can appear two or three times and appear to react to themselves in the image. Each exposure must be a fraction of the whole; otherwise it results in overexposure. Three images on one frame equals one third of the overall exposure each. In the darkroom, sandwiching two negatives together and making a single print from the combined images can produce a similar effect.

Some digital cameras now feature a multiple-exposure function.

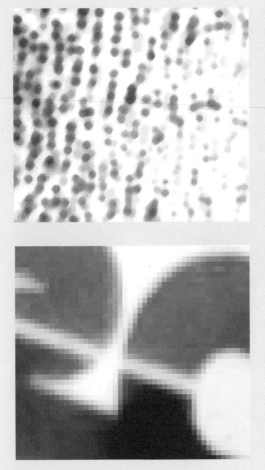

DPI (dots per inch) is a measure of how many droplets (dots) of ink an inkjet system can fit into a linear inch. This is not a measure of image detail or resolution as the dots have to be laid down in a matrix pattern to create the appearance of a colour.

PPI (pixels per inch) is a measure of the resolution of digital images, cameras and scanners and can be thought of as the degree of refinement of the digital sampling process. DPI is commonly and mistakenly used for PPI.

In high-quality books, black-and-white photographs are often printed as duotones. As the name suggests, this involves two inks: one ink, usually black, carries the darker tones in the image. A second ink, usually a warm or cool grey, is used for lighter tones. The combination gives the printed images a greater tonal subtlety, close to a real silver gelatin fine print. The two colours need not be black and grey; computer duotones can be created from a greyscale original in any two colours; tritones use three inks and quadtones four. The inks can be designated as spot Pantone inks or process colours from cyan, magenta and yellow. An ink coverage curve is designed so the ink is specific to a particular tonal range.

Process duotone

Pantone 478 duotone

Pantone 313/127 tritone

☞ see Monochrome 166

THIS IS A DIRECT POSITIVE COLOUR PROCESS WHERE THE COLOURS ARE ALREADY HELD IN DYES IN THE RECEIVING 'PAPER' (ACTUALLY A HIGH-GLOSS PLASTIC). THE MATERIAL IS EXPOSED TO A PROJECTED POSITIVE IMAGE (A COLOUR SLIDE) AND IN PROCESSING THE UNWANTED COLOURS ARE 'DESTROYED' TO LEAVE A VIBRANT, SATURATED COLOUR IMAGE ON A HIGH-GLOSS SUPPORT. ORIGINALLY DEVELOPED BY THE DRUG-AND-CHEMICALS GIANT CIBA-GEIGY, IN SWITZERLAND IN THE 1960S, THE CIBACHROME PROCESS WAS BOUGHT BY ILFORD, THE UK PHOTOGRAPHIC COMPANY. ILFORD MARKETED THE PRODUCT AS CIBACHROME FOR TEN YEARS BEFORE RE-BRANDING IT AS ILFOCHROME CLASSIC. IT IS A HIGHLY STABLE PROCESS.

Also called 'thermal' printing, this has to be one of the most unlikely imaging processes. Sublimation is the state change of a solid to a gas without going through the usual liquid state (i.e. ice-water-steam). Ribbons of red, yellow and blue dye are heated in proportion to the amount of each colour in the image. These sublimate (gas off) on to a receiving paper. Three passes produce the image while a fourth pass lays down a protective gloss coating. Dye sublimation is capable of good resolution and excellent colour saturation, although blacks may not be completely neutral. Despite its being wasteful of the unused dyes and only usable with special paper, dye-sub printers are regularly used in digital kiosks and by events photographers. Some manufacturers make small domestic dye-sub printers.

Above: section of dye-sub ribbon showing blue, red and yellow dye sections. Ribbon has to cover the full width of media.

Left: high-gloss finished prints with highly saturated colour.

Dynamic range is the ratio between minimum and maximum light intensities that can be recorded by a specific medium — usually reported in stops. A 2:1 ratio is a 1-stop dynamic range; 256:1 an 8-stop range and 4096:1 a 12-stop range. Most digital cameras offer a 10-14 stop theoretical dynamic range, which translates practically as an 7/8-12 stop range because of pixel size, lens flare, noise and other real-world problems. Digital SLRs shooting in Raw format are in the 10-12-stop performance bracket. Film starts with the limited 5-stop (32:1) range for colour reversal material. Negative materials can easily handle 7-stops and possibly up to 10-stops for some colour negative and black-and-white films, with care over exposure relative to subject contrast and appropriate development compensation.

Digital

Negative

Colour neg

Slide

☞ see Colour Negative Film 67, Colour Reversal Film 68, Negative/Positive 171, Raw Format 199

Born in 1854, in Waterville, NY, George Eastman worked in a bank to support his widowed mother and sisters. However, his interest in photography led him to establish a company to sell his improved gelatin dry plates. In 1884 he patented a paper roll film, forerunner of the flexible roll film that would revolutionise still photography and make the movie industry possible. In 1888 he registered the trademark Kodak as a unique word pronounceable in any language and in two years had sold over 100 pre-loaded Kodak cameras. Eastman Kodak rapidly became the photographic giant known as 'Big Yellow'. Marketing was Eastman's forte; he introduced the Brownie camera for children (based on a popular cartoon imp) and cameras for women. His slogan 'you press the button, we do the rest' summarised his company's popularist approach. Eastman ended day-to-day involvement with Kodak in 1925. A generous benefactor to education, dentistry (Eastman Schools of Dentistry) and the arts, he took his own life on 14 March 1932, leaving a note that read: 'My work is done, why wait?'

Harold 'Doc' Edgerton (1903–1990) has become known as the father of flash photography. He investigated turning electric motors with the pulsed flashes of light from a stroboscope as part of his doctoral work. The stroboscope (flash units in America are still known as 'strobes') could pulse light from an electric spark up to one million times a second. Edgerton worked with the photographer Gjon Mili in applying this light to still photography, where it could be used to imprint many images of a moving object on one piece of film. Edgerton used higher-power single flashes to 'freeze' the motion of everyday events, such as this single drop of milk, to create unique images never before seen.

Milk Drop Coronet, 1957.

☞ see Flash 120

Eggleston's influence on visual culture has been profound. Born in Memphis, Tennessee, in 1939, Eggleston began experimenting with colour negative and transparency materials in simple rangefinder camera in the early 1960s. In 1967 he visited New York, armed with a suitcase full of work, meeting Diane Arbus, Gary Winogrand and Lee Friedlander. They introduced him to John Szarkowski, the highly influential curator of the New York Museum of Modern Art. In 1976, Szarkowski arranged a ground-breaking exhibition at MoMA of Eggleston's colour images, the first solo colour exhibition at the museum and recognition that the era of black-and-white documentary photography was over. Eggleston's seemingly mundane, highly saturated colour images present an everyday world loaded with potential significance. Critics were at first baffled but Eggleston's revelation of the everyday has informed filmmakers, designers and photography to a remarkable degree.

A child's trike, given monumental proportions, featured on the cover of *William Eggleston's Guide*, a series of essays by John Szarkowski (MoMA, NY, 1976 and 2003).

The electromagnetic spectrum includes high-frequency, short-wavelength energies such as gamma ray and X-ray that are used in medical imaging as well as longer wavelength, low-frequency radiation used in microwave cookers and mobile phones, television and radio. The visible spectrum – light – is a very narrow band of electromagnetic radiation to which the human eye is sensitive.

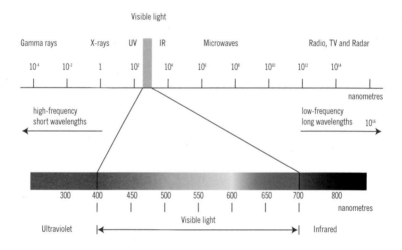

The visible spectrum is the range of colours that exists between 400- and 700-nanometre wavelengths. These are the familiar colours of the rainbow (red, orange, yellow, green, blue and violet – modern science no longer treats indigo as a usefully separate colour). Ultraviolet light lies to one side of the visible spectrum and infrared radiation to the other.

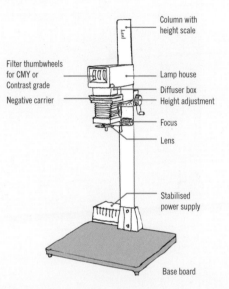

Column with height scale

Filter thumbwheels for CMY or Contrast grade

Lamp house

Diffuser box

Negative carrier

Height adjustment

Focus

Lens

Stabilised power supply

Base board

To make a usable print from a miniature-format negative, the image will need to be enlarged, i.e. made bigger to reveal detail to the unaided eye. This process is known as enlargement and the device that makes enlargements is a photographic enlarger.

The enlarger works like a camera in reverse, with the light source inside the sealed box. This projects a magnified image of the negative through a lens to a baseboard where photographic printing paper is placed. Raising the enlarger head makes the image bigger. Exposure is worked out by printing test strips using the Law of Reciprocity: intensity is adjusted by the lens aperture and duration by an electrical timer on the lamp. Colour enlargers feature a mixing box in the head for cyan-, magenta- and yellow-filtered light; for variable-contrast papers, multigrade enlargers have filters to directly set the contrast grade.

☞ see Negative/Positive 171, Reciprocity 200

Part of the kitchen (Home of sharecropper Floyd Burroughs, showing washstand in the dog run and a view into the kitchen, Hale County, Alabama, 1936).

Although Walker Evans's (1903–1975) best-known work was done for the Farm Security Administration (FSA), documenting the effects of the Great Depression on the American South, he was a somewhat reluctant contributor to the project. Almost incidental to his FSA work was a project with the writer James Agee that finally saw light of day as the pioneering book *Let Us Now Praise Famous Men*, a disturbing, though moving, account of rural poverty. Ever a photographic perfectionist, Evans's work was recognised as important enough for his to be the first ever solo exhibition by a photographer: 'American Photographs' was shown at the Museum of Modern Art in New York (1938).

EXIF stands for **EX**changeable **I**mage **F**ile format for digital still cameras. This is an image format published by the Japan Electronics and Information Technology Industries Association (JEITA), as part of its Design Rules for Camera Files (DCF) standard. It is a standard for storing and exchanging data between imaging devices. Supported by nearly all digital cameras, it has been in use since October 1996. Key data stored includes image size and type, copyright, camera model and manufacturer, lens focal length, exposure information (including flash data), ISO setting and white balance.

Above: The original image of the Duddon Estuary in Cumbria, UK, contains information in the file header that does not appear when the file is printed, but which can be displayed using appropriate software.

Above left: PhotoInfo by Jim Merkel allows the user to display and print EXIF information from the digital file.

☞ see Metadata 161

Exposure is the act of making a photograph. Technically, it is also the total amount of light that is allowed to fall on the film or sensor in the camera. Light falling on the photosensitive material has intensity or brightness (how wide the lens aperture is) and duration (how long the shutter is open). An appropriate combination of intensity and duration for the sensitivity of the film or sensor will give a good exposure, containing details in both shadows and highlights. The aperture and shutter speed can be set manually on the camera for each exposure, or this process can be automated. Pictured is an average scene, made slightly darker for aesthetic purposes, exposed digitally with a sensitivity of ISO 100, a shutter speed of 1/80 sec and an aperture of f/3.5.

Overexposure occurs when there is too much light. The aperture could be too wide, the shutter speed too long or the film speed incorrectly set too low. With digital cameras and slide films the result is a thin, washed-out image. The highlight detail is gone completely – these highlights are described as being 'blown out'; no amount of digital editing will recover the lost data here. With negative film, an overexposure is a very dark, thick-looking image – distinguishable from overdevelopment as the edge markings on the negative will appear normal, not dark, and smudged.

Underexposure happens when there is not enough light. Although neither is recommended, it is easier to correct an underexposed digital image than one that is overexposed. The aperture could be too small, the shutter speed too short or the film speed set too high. Underexposure with negative film results in a thin image, which prints dark with no shadow detail at all. For digital and slide film the result is a dark image with 'blocked-up' shadows that are inky black and without detail.

☛ see Highlight 138, Reciprocity 200, Shadow 218, Zone System 270

Reflected light meters – like the one in your camera – are calibrated to provide an exposure reading that will reproduce an average scene, i.e. mid-grey. An overall dark scene will be overexposed to produce a grey image and a light scene will be underexposed to appear grey – as shown in the auto-exposure images taken of all-black and all-white objects. Camera manufacturers provide a manual compensation to overcome this problem; EV or Exposure Value compensation. The button is usually marked with a square symbol divided diagonally with a plus and a minus sign. Adjustment is made in stops.

Black Auto

Black -2EV compensation

White Auto

White +1.5EV compensation

EV - Table of exposure values (ISO 100)													
	f-number												
shutter (s)	1	1.4	2	2.8	4	5.6	8	11	16	22	32	45	64
60	-6	-5	-4	-3	-2	-1	0	1	2	3	4	5	6
30	-5	-4	-3	-2	-1	0	1	2	3	4	5	6	7
15	-4	-3	-2	-1	0	1	2	3	4	5	6	7	8
8	-3	-2	-1	0	1	2	3	4	5	6	7	8	9
4	-2	-1	0	1	2	3	4	5	6	7	8	9	10
2	-1	0	1	2	3	4	5	6	7	8	9	10	11
1	0	1	2	3	4	5	6	7	8	9	10	11	12
1/2	1	2	3	4	5	6	7	8	9	10	11	12	13
1/4	2	3	4	5	6	7	8	9	10	11	12	13	14
1/8	3	4	5	6	7	8	9	10	11	12	13	14	15
1/15	4	5	6	7	8	9	10	11	12	13	14	15	16
1/30	5	6	7	8	9	10	11	12	13	14	15	16	17
1/60	6	7	8	9	10	11	12	13	14	15	16	17	18
1/125	7	8	9	10	11	12	13	14	15	16	17	18	19
1/250	8	9	10	11	12	13	14	15	16	17	18	19	20
1/500	9	10	11	12	13	14	15	16	17	18	19	20	21
1/1000	10	11	12	13	14	15	16	17	18	19	20	21	22
1/2000	11	12	13	14	15	16	17	18	19	20	21	22	23
1/4000	12	13	14	15	16	17	18	19	20	21	22	23	24
1/8000	13	14	15	16	17	18	19	20	21	22	23	24	25

An Exposure Value is a method of stating exposure settings using a single number to represent a range of equivalent combinations of aperture and shutter speed. The Exposure Value unit is one stop. EV0 is a shutter speed of 1 sec at f/1.0 and ISO 100. The average room interior would be EV5-7, an overcast day EV10-12 and full sun EV15-16.

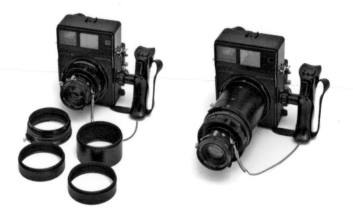

A set of extension tubes (left) can be used individually, in combination or all together (right)
between the lens and camera body to achieve a range of magnifications.

The easiest way to increase image magnification in close-up or macro photography is to move the lens further away from the image plane. This is done by placing rings or tubes – often supplied in sets – between the camera body and lens. If the tube length is the same as the focal length, then the reproduction will be life-size. Shown is a set of extension tubes for a classic 6x9cm Mamiya Press camera. Rings and tubes from the same set can be mixed and matched to give a range of magnifications.

☞ see Bellows 40, Macro Photography 157

In 1855, Roger Fenton (1819–1869) was assigned to photograph the troops and scenes of the Crimean War. His cumbersome wet-plate equipment and darkroom, in a large horse-drawn wagon, limited his choice of subject; consequently, his portfolio of over 300 large-plate images published on his return to England was not a major success. This image, taking its contemporary title from one of the *Psalms*, shows the site of the infamous Charge of the Light Brigade (a British military blunder where cavalry was ordered to charge Russian artillery and infantry positions; there was a loss of almost half of those who took part). Fenton's photographic equipment was so cumbersome that he could only photograph the aftermath, but this image, showing the valley strewn with round shot, chillingly depicts the intensity of fire directed against lightly armed cavalrymen. It is one of the earliest war photographs and certainly one of the most poignant.

The Valley of the Shadow of Death, 1856.

☞ see Collodion Process 58

Fill light is used to illuminate the shadows cast by key (main) light. The fill can come from reflectors or from a separate lamp or flash head acting as a fill light. A fill light puts a controlled amount of light into the shadow areas created by the main light to reveal some detail. The fill light reduces the lighting ratio and controls the contrast in the image, preventing the subject from being too contrasty and allowing the camera to capture both highlight and shadow detail.

Finished portrait with key and fill light

Fill light only

Key light off

see **Key Light** 149, **Reflector** 203

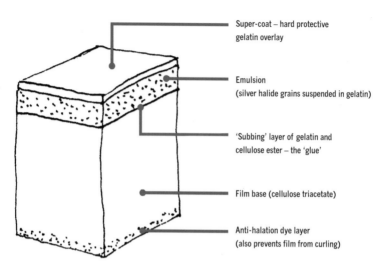

Super-coat – hard protective gelatin overlay

Emulsion (silver halide grains suspended in gelatin)

'Subbing' layer of gelatin and cellulose ester – the 'glue'

Film base (cellulose triacetate)

Anti-halation dye layer (also prevents film from curling)

In black-and-white film, there is usually just one layer of silver salts that reacts to light during exposure to create a latent image. This is developed to produce a negative with black metallic silver where the film was exposed to light. An anti-halation dye layer is used to stop light bouncing around within the film itself, spoiling the image. A hard gelatin surface coat can be used to protect the film while 'subbing' layers are used to stick the various layers to the clear film base.

Colour film is a complex, multi-layered product with up to 16 layers of dyes, chemical couplers and silver halide for each of the three primary colours.

☞ see Developer 87, Negative/Positive 171, Silver Halide 228

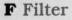

Filters are transparent glass or plastic devices that modify light passing through
the camera lens. Some alter the colour of the light, some its physical properties.
The latter type – including neutral density filters, graduated filters and polarisers –
are used with both film and digital cameras. Most of the colour filters used for
changing the colour temperature of an image, or for the creation of specific black-
and-white effects, can only be used with film. Filters may be circular screw-in types
or rectangular for use in a filter holder. Thin gelatin filters are less often seen today
and require a gel-holder.

A red filter blocks much of the blue and green light so they will show darker than the red
light, which passes through. So a red filter can be used to darken blue skies. The general
rule: to darken a colour, use a filter of the complementary colour; to lighten a colour, use
the same colour filter.

Filter also refers to a computer software module that applies an image effect.

These are classic
filters for black-
and-white film
photography: yellow-
green lightens the
appearance of foliage;
yellow strengthens
cloud structure; orange
and red dramatically
darken skies. Filters
pass light of their own
colour but block the
remainder.

☞ see Colour Conversion Filters 62, Colour Correction Filters 63,
Complementary Colours 71, Wratten Filter System 269

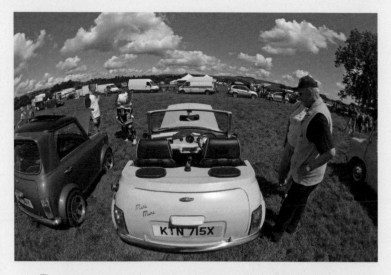

These extreme wide-angle, short focal-length lenses were
first developed for meteorology to photograph the whole sky;
some have an angle of view greater than 180°. Advertising
photographers discovered them in the 1950s. They come in two
types: those that give full circular images and those that are
cropped to the rectangle or square of the image format. Although
straight lines in the image all appear to have massive curvature,
you will notice that any line passing through the middle of the
picture is quite straight. Focusing is almost redundant thanks
to the tremendous depth of field. Front elements are always
massive and filters are usually fitted to the rear.

Shown is a customised Mini at a local fête, shot with a Nikon 10.5mm f/2.8G AF DX Fisheye.

☞ see Angle of View 26

After development, a special chemical is needed to create a permanent, fixed, image. The generic term is fixer. It is needed for both film and paper. Fixing agents, one of the last pieces of the photographic jigsaw, were proposed by Sir John Herschel and used by Fox Talbot in about 1841. Fixers work by converting unused silver halides to water-soluble compounds, which can then be washed out of the film where, if left, they would darken on exposure to light. Two chemical groups – the thiosulphates and cyanides – provided suitable candidates. Sodium thiosulphate (or hypo, from the old chemical name hyposulphite of soda) proved the cheapest. Some cyanide fixers, which can be highly poisonous, are used by contemporary ambrotypists. Ammonium thiosulphate is a common ingredient of modern rapid fixers, some of which have a gelatin hardening agent and water-softening compounds added.

☞ see Calotype 47, Developer 87, Photography 186

The Mineshop at the North of England Lead Mining Museum, County Durham, UK. Image taken using a wide-angle lens (without lens shade to maximise flare), 1/160 sec at f/5.6.

Flare is any non-image-forming light, which usually occurs when the camera is pointed towards a light source. Light can bounce about between the lens elements to create a cascade of bright lens flares. It also causes a general degradation in image saturation and contrast. All these effects can be seen in this image. High-quality surface coatings on lenses and filters reduce flare, as do lens hoods.

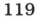 see Lens Hood 155

Flash is a powerful but brief form of photographic light. It is distinct from continuous light, which is any light source that shines without break or interruption – usually tungsten or fluorescent lights. Originally, the flash came from burning magnesium dust. Flash bulbs, ignited by an electrical current were safer – the modern capacitor-charged electronic flash can be used again and again and its output adjusted. The flash has a brief duration and must be synchronised with the opening of the camera shutter. Flash can be balanced to other light sources (fill flash). Some cameras feature built-in flash of limited power. Flashguns that connect to the camera hot shoe are more powerful; studio flash heads (strobes) with integral power supplies are more powerful still.

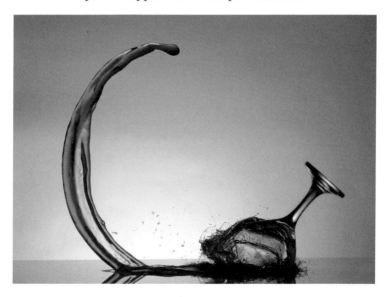

☞ see Edgerton, Harold Eugene 102

Above: Photon Beard Highlight and Intensifier – daylight balanced fluorescent lamps for studio use.

Fluorescent lights are glass tubes containing a small amount of mercury in a part-vacuum. Electric current is passed through the tube causing the mercury vapour to emit strong ultraviolet (UV) light. The inside of the tube is coated with fluorescent phosphors that absorb much of the UV and give out visible light. The exact colour of light from a fluorescent lamp depends on the mixture of phosphors; this is usually a combination of green and orange/magenta light, with spikes at 430, 550 and 610 nanometres in inexpensive tubes.

The car shown was shot on film without a filter for fluorescent light. It is top-lit by weak daylight, which shows the true colour, but side-lit by fluorescents – the green cast is how this light shows on daylight film. An FL-D filter is needed for correction; how effective this is depends on the exact output of the fluorescent light. Fluorescent strip lights balanced for daylight colour temperature are now more common in photographic studios, being easier to use than flash (strobes) and cooler-running than tungsten lamps.

☞ see Electromagnetic Spectrum 104, Tungsten 255, White Balance 266

Aperture is defined as the 'diameter of the lens opening as a fraction of the focal length'. So if a lens has a focal length of 100mm and an effective aperture of 25mm the relative aperture is 100/25 = 4/1 Aperture = 4. This is expressed as f/4, f4 or even 1:4. The standard sequence of whole-stop f-numbers is shown; each has half and double the light intensity of its neighbours. Half-stop values (such as f/1.7) and one-third stop values (such as f/7.1) will be found on modern cameras where aperture is adjusted electronically.

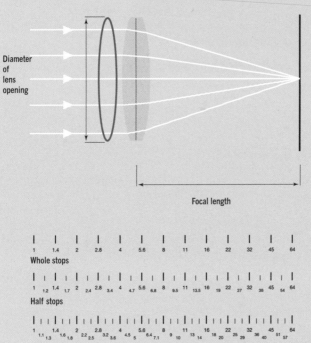

Diameter
of
lens
opening

Focal length

| 1 | 1.4 | 2 | 2.8 | 4 | 5.6 | 8 | 11 | 16 | 22 | 32 | 45 | 64 |

Whole stops

| 1 | 1.2 | 1.4 | 1.7 | 2 | 2.4 | 2.8 | 3.4 | 4 | 4.7 | 5.6 | 6.8 | 8 | 9.5 | 11 | 13.5 | 16 | 19 | 22 | 27 | 32 | 38 | 45 | 54 | 64 |

Half stops

| 1 | 1.1 | 1.3 | 1.4 | 1.6 | 1.8 | 2 | 2.2 | 2.5 | 2.8 | 3.2 | 3.6 | 4 | 4.5 | 5 | 5.6 | 6.4 | 7.1 | 8 | 9 | 10 | 11 | 13 | 14 | 16 | 18 | 20 | 22 | 25 | 29 | 32 | 36 | 40 | 45 | 51 | 57 | 64 |

Third stops

☞ see Aperture 27, Focal Length 123, Reciprocity 200

For a simple lens the focal length is the distance from the centre of the lens to the point of focus. With a camera lens comprising a set of lenses in groups, the 'focal length' is technically the effective focal length – it gives us a good working idea of how the lens would perform if it were a simple lens. Optically, it is really a measure of how strongly the lens focuses the light; practically speaking, it is a measure of the angle of view and, as we always use the lenses with a fixed image size inside the camera, a means of comparing optical power for that particular format.

All lenses of the same focal length give images of the same size. Image size is in proportion to focal length, so changing from a 50mm to a 100mm lens, for example, will double the image size.

Common names for lenses from 35mm cameras (or digital equivalents)	
12–20mm	Ultra-wide-angle
21–24mm	Super-wide-angle
28–35mm	Wide-angle
45–60mm	Standard
75–105mm	Short telephoto 'portrait'
135–200mm	Telephoto or long-focus
300mm and above	Extreme long-focus

☞ see Angle of View 26, Aperture 27

Technically speaking, the focal plane is the imaginary flat surface inside the camera where the image is focused. There is also an imaginary flat surface that cuts through the subject where the lens is focused, which should correctly be called the field plane. This is what working photographers often mean when they refer to the focal plane, but they should use the phrase 'plane of focus'. In a conventional camera, this is parallel to the film or image plane and the lens plane. In a technical or view camera, the plane of focus can be altered using movements of the camera back and lens board.

This image unusually shows a plane of focus that falls vertically through the picture, with both the left-hand and right-hand sides of the image being out of focus rather than the foreground and background. This image is a scan from a positive black-and-white Polaroid print, which was taken with an Ebony SW45 (5x4 field camera), Nikkor-SW 90mm f/4.5.

☞ see Scheimphlug Principle 214

The focal-plane camera shutter is a travelling slit shutter that operates close to the film/sensor in the plane of focus of the lens. It is common in digital SLRs and 35mm film cameras. The shutter comprises an adjustable slit between two 'curtains', which travels to expose the film/sensor to light. These curtains can be made of rubberised cloth, metal foil or plastic; some travel vertically, some horizontally. Moving objects appear lengthened when travelling in the same direction as the shutter blinds but shortened when travelling in the opposite direction. To synchronise properly with flash, the slit must be wide enough to expose the whole film/sensor; this limits the maximum shutter speed at which flash synchronisation can occur with a focal-plane shutter.

☞ **see Shutter 222**

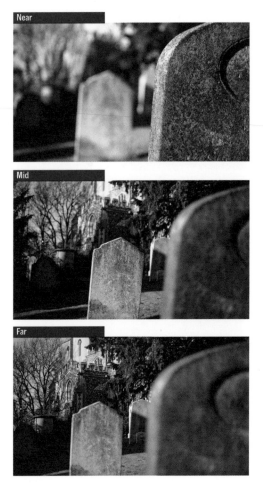

Focus is achieved by altering the distance between the lens and the film/sensor plane to produce the sharpest image. Manually focused camera systems feature different focusing aids, including split images (common in rangefinders), a collar of microprisms, split prisms or a flat concentric Fresnel lens (all used in SLR cameras). Autofocus cameras may offer in-focus confirmation when manually focused lenses are mounted – a feature sometimes referred to as an electronic rangefinder.

see Autofocus 35, Focal Plane 124, Lens 154

There are three main formats in film photography: Medium (MF); Large (LF) and miniature format (35mm and smaller). Medium-format photography uses 120 roll film; large-format photography is generally done on sheet film. These sheets of film may be up to 10x8 inches. They are loaded individually in a cut-sheet film holder or in pairs in a double dark slide. 35mm cameras take the so-called miniature format 135 film in cassettes. Various image sizes can be laid down on each film, although roll film is most flexible in this respect. Half-frame 35mm photography had its heyday in the late 1960s and early 1970s. APS film cassette was the last major format introduction and offered greater advantages to the consumer and photo processing labs than either 110 or 126 cassette formats. Kodak's Disk format was very short-lived. Digital cameras offer either the 35mm aspect ratio or the Four Thirds format, although some feature an additional 16:9 HDTV format.

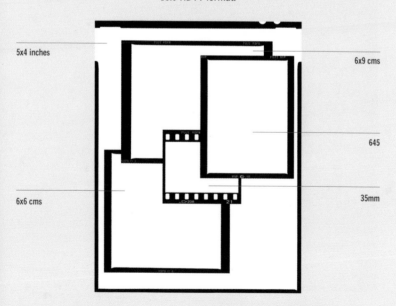

5x4 inches

6x9 cms

645

6x6 cms

35mm

☞ see Aspect Ratio 32, Double Dark Slide 94, Roll Film 209

Robert Frank was born in Switzerland in 1924. He had already lived and worked as a photographer in the USA when he managed, with the influence of Walker Evans, to secure a grant to travel around the country to photograph its people. Disheartened by the American way of life, Frank was ripe to document American society through the critical eyes of an outsider. Frank's extraordinarily edgy and dynamic photographs were married to a text by beat poet and writer Jack Kerouac. The combination was too powerful a critique for American publishers and *The Americans* was first published in France in 1958. Despite its massively influential status it was only recently published in a definitive edition, supervised by the photographer, by Steidl in 2008. Frank has continued to influence generations of photographers and filmmakers alike.

Lee Friedlander (born 1934) was one of the major new talents in 1960. His work was featured in the highly influential exhibition Towards a Social Landscape, curated by Nathan Lyons at the George Eastman House in Rochester, New York. Working with Leica 35mm cameras and black-and-white film, Friedlander investigated the present moment and the social landscape. Much of his work, done on city streets, references and explores the artificiality of photographic framing in its use of frames within frames, window reflections and shadows.

Frith (1822–1898) was a successful businessman and founder of the Liverpool Photographic Society. He sold his printing business to finance a series of photographic expeditions to the Middle East. The images were initially published in other photographers' books but by 1859 Frith had founded his own company to publish postcards and market travel images. The company became one of the largest publishers of views of Britain and abroad and sent out photographers to capture every major town and location. Images from the collection are nowadays available online.

The Sphinx and the Great Pyramid, Gizah, Egypt, taken by Frith in the late 1850s.

Front or frontal lighting comes straight towards the subject from a little above and behind the camera; this creates what is usually described as 'flat' lighting. The light is not angled to the surface of the subject facing the camera so the appearance of texture is minimised. Because there are no long shadows cast, contrast is reduced. Square-on front lighting produces little or no modelling of the subject (hence the lower contrast) and does not emphasise volume or form in any way. Shadows will fall behind the subject and are not seen by the camera. Slightly off-axis lighting will begin to shape the subject and give just-visible shadow lines. Early colour film needed exposing in this kind of light – the advice was to always have the sun on your back – to avoid high-contrast lighting that the film's limited dynamic range could not handle.

☞ see **Backlighting** 37, **Rim Lighting** 207, **Side Lighting** 225, **Three-quarter Lighting** 246

Giclée is the feminine past participle of the French verb *gicler*, which means to squirt or spurt. It was used – originally in America – to avoid having to apply the description 'large-format ink-jet print' for fine-art reproductions of artists' work. Photographic galleries found that ink-jet copies of classic images were better accepted by collectors when described as giclée prints (although there is a now a move away from even high-quality ink-jet prints towards digitally printed traditional darkroom materials, at least for black-and-white images).

☞ see Inkjet 143

GOBOS ARE PERFORATED METAL DISCS WITH PATTERNS
OR SYMBOLS CUT INTO THEM AND USED IN SPOTLIGHTS
TO PROJECT THE PATTERN ON TO THE SUBJECT OR
BACKGROUND. THEY ARE SOMETIMES REFERRED TO AS
'COOKIES' BECAUSE OF THEIR BISCUIT-LIKE SHAPE AND
DIMENSIONS. GOBO, WHICH IS SHORT FOR 'GO-BETWEEN',
CAN ALSO REFER TO LARGER, PHOTOGRAPHIC FLAT BOARDS,
PERHAPS MADE OF CARD OR FOAMBOARD, WHICH GO
BETWEEN A LIGHT SOURCE AND THE SUBJECT OR
BACKGROUND TO CAST A SHADOW.

'Graduated' means a gradual change from one density (usually clear) or one colour to another density. The filters are partly toned resin or plastic, with slightly more than half of the filter clear. The clear-to-toned area has a smooth transition. The most useful graduated filters, or 'grads' as they are commonly called, are the neutral density (ND) sets. ND grad filters can have two variables. First, how much light the neutral density section cuts down; secondly, the rate of transition from clear to toned, usually described as being soft or hard. ND grads are used to darken skies or control contrast to keep subject brightness range within the limits of the recording medium.

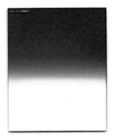

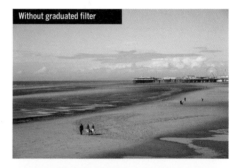
Without graduated filter

The best ND grads are rectangular, fitting into a slotted holder over the lens. Both can then be rotated and the filter moved up and down so the transition can be placed across the image just where it is needed.

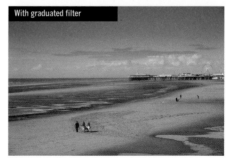
With graduated filter

☞ see Filter 116, Neutral Density Filter 172

Grain is unique to film photography. The tiny 'sensitivity specks' of silver in the latent image from the camera become visible clusters of metallic silver during development. Grain is random in shape and distribution (quite unlike digital noise), while its size largely depends on film speed. Fast films produce bigger grain when developed. Grain is strongly associated with gritty photographic realism because of the amount of hard-hitting, classic social-documentary photography shot on grainy, high-speed film under available light. This is now referenced by fashion and fine-art photographers. Grain is less apparent in colour imagery as these processes do not usually retain the image-forming silver and instead rely on dyes for their image structure.

☞ see Noise 175

The focusing screen on a large-format view camera lies
in the film plane. It shows the image exactly as it will
appear; it is viewed upside down and laterally reversed.
Screens are made of glass, with the surface finely ground
to show the image. The other smooth side may have
format or composition lines printed. A chinagraph pencil
can be used to temporarily mark the screen as an aid to
composition. The actual image is very dim and must be
viewed in the shade provided by a darkcloth, though
sometimes a flat Fresnel lens is fitted over the screen
to make it brighter and easier to focus.

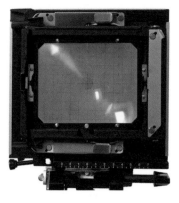 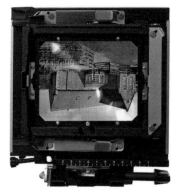

This image of the screen on a 5x4 camera
has been enhanced to show how the image
appears under the cloth.

☞ see Darkcloth 82, View Camera 261

-3EV

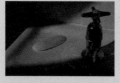

-2EV

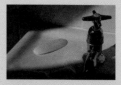

-1EV

Metered

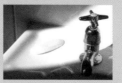

+1EV

+2EV

Pictured is a high-contrast scene recorded in a range of seven images from +3 stops to –3 stops and the resulting tone-mapped HDR image with full highlight and shadow detail.

+3EV

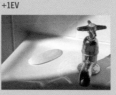

HDR

High Dynamic Range (HDR) photography addresses the problem that camera systems can only record a limited dynamic range, which does not correspond with our perception. A series of images across a range of exposures is taken and the resulting stack turned into a single HDR image, containing many more levels than can actually be displayed on our limited dynamic-range screens or monitors. The 32-bit depth HDR images are interpreted using a technique known as tone mapping, to reveal highlight and shadow detail that matches human perception of the scene.

☞ see Dynamic Range 100, Tone Mapping 252

This picture shows the highlight areas in a conventional landscape image using false colour (red).

Highlights are the lightest areas in an image. In a five-stop image, the highlights are considered to be the highest tonal values above the quarter-tones, mid-tones, three-quarter-tones and shadows. In some image-editing software, the tone curve is only divided into four regions – the tones in the top quarter are considered highlight tones.

☞ see Histogram 139, Shadow 218

A histogram is a bar chart that displays the numbers of pixels in each colour intensity level. The simple histogram usually shows 256 levels of brightness from 0 to 255 where black is 0, mid-grey is 128 and white is level 255. White is usually to the right of the graph with all the light tones to the right and above mid-grey and all the dark tones falling to the left. Vertical height is unimportant as the category with the biggest pixel count is made to fit the maximum vertical height on the display. Some camera histograms are divided up to show a 'safe' five-stop range. There is no such thing as a perfect histogram – the shape of the chart depends entirely on what is in front of the camera. Dark subjects will show a bias to the left, light subjects a bias to the right, high-contrast subjects a classic U-shaped chart and average subjects a central hump shape. Some cameras show red, green and blue channels independently.

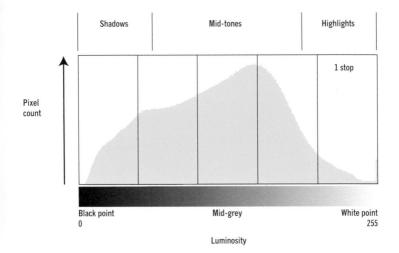

see Clipping 57

The English painter famously protested, 'I've finally figured out what's wrong with photography. It's a one-eyed man looking through a little 'ole.' Despite this, David Hockney (born 1937) has used photography in his art and greatly influenced how contemporary photographers see the world. Initially using colour film and supermarket prints – later supported by Polaroid – Hockney began to explore the limitations of conventional perspective in his 'joiners' – first gridded and then loosely arranged sequences of images taken from a range of viewpoints. Intriguingly, not only does Hockney's technique deliver more of the third dimension into a two-dimensional medium but it also addresses the depiction of the passing of time in a static medium much more convincingly than any time exposure.

Pearblossom Highway 11–18th April, 1986, #2.

Pictured is a photocollage of many hundreds of prints contrasting the views of passenger (left side) and driver (right side) in a commentary on subjectivity and supposedly objective vision.

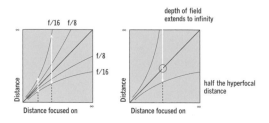

This image of Carlisle Cathedral was focused using this principle, with an 18mm lens on a digital SLR and a crop factor of 1.5, which dictated a hyperfocal focusing point of just over 1.5m.

Focusing at the hyperfocal distance gives maximum depth of field extending from half that distance to infinity. Hyperfocal distance calculators are available either as computer software or as look-up tables and plastic dials for use in the field. The formula for the mathematically minded is:

$$H = (L^2)/(f \times d)$$

H is the hyperfocal distance; L = focal length (mm); f = the aperture; d = circle of least confusion (mm). This last value has to be taken into account as there needs to be some standard for acceptable sharpness in determining the limits of depth of field. The values of d for a traditional 10x8in print are 0.03 for 35mm/full-frame digital; 0.06 for 6cm square film and 0.15 for 5x4 sheet film.

☞ see Circle of Confusion 56, Depth of Field 85

Film is normally sensitive to just blue/green light (orthochromatic) or has extended sensitivity into the visible reds (panchromatic). True infrared films show sensitivity to longer wavelengths out beyond visible red into the infrared region; the so-called near red films have extended red sensitivity. Kodak's High Speed IR film defined the classic look of infrared images. It is no longer made although some manufacturers still produce true IR film.

Digital sensors may have sensitivity beyond the visible spectrum but nowadays this is limited by a filter placed by the manufacturer over the filter. Some older digital cameras had extended IR sensitivity and are sought by IR enthusiasts. Some digital cameras can be converted by removing the filter for dedicated IR photography.

Infrared film is usually exposed through a deep red filter – sometimes almost black – to cut out all blue/green light and much of the visible red spectrum. This gives the distinctive, otherworldly look of black skies and white foliage. Picture shot on Kodak high speed infrared film using a Hoya 25A Red Filter.

☞ see Electromagnetic Spectrum 104, Filter 116

Inkjet printers weave their images from tiny ink droplets (as small as 2 picolitre) sprayed on to the paper from jets. Up to 5,760 dots per inch can be laid down in patterns (dithering) to give the appearance of continuous colour tone from just four inks. Many technologies are employed: some heat the ink drop in a tiny tube, blowing it out on to the paper (thermal inkjet); others involve piezoelectric materials that flex when an electric current is applied to push the ink out as a bubble or drop (hence Canon's Bubblejet).

Inkjet printers use at least three inks (cyan, magenta and yellow) and sometimes many more, including light versions of the cyan, magenta, yellow and black inks, as well as specially mixed inks for difficult-to-reproduce colours (orange). Inkjet is now the dominant printing technology.

☛ see Dye Sublimation 99, Giclée 132, Subtractive Colour 241

The inverse square law states: the intensity of light observed from a constant source falls off as the square of the distance from the source. This is why it gets dark so quickly when you move away from a campfire at night. Put simply, the inverse square law means that as you double the distance from the light source you quarter the light intensity: at four times the distance it is 1/16th as bright. In fact, the light falls off as one over the distance multiplied by itself. It is important to understand this law, as it is one of the main ways in which the brightness of photographic lighting can be controlled in the studio.

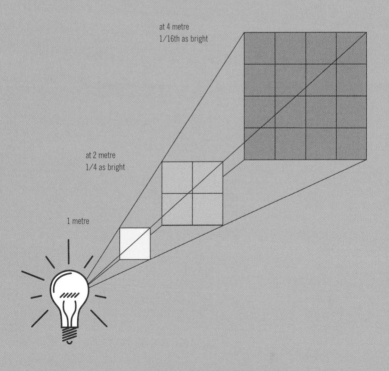

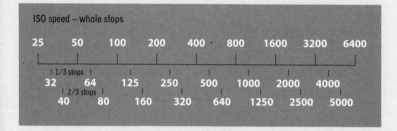

Film speed is a standardised measure of the speed at which the film reacts to light. Various systems were used around the world from national standard-setting bodies. These were then rationalised by the International Organisation for Standardisation into the familiar ISO numbers. ASA numbers were arithmetic and used in America and Japan; DIN numbers used in Europe were based on a German logarithmic scale. Both systems survive in the full ISO number – ISO 100/21˚ (arithmetic/logarithmic) used for film speed. We tend now to use only the arithmetic value where double the number means double the speed – one stop faster. Digital sensitivity is analogous.

JPEG stands for the Joint Photographic Experts Group. The JPEG committee was created in 1986 to look into the standardisation of a digital image format (among other things) and has become synonymous with the JPEG file format and compression standard it proposed. A revised format was introduced in 2000. The JPEG file was originally developed to fit lots of digital images in to what was then very expensive memory.

JPEG files use lossy compression to save file space by throwing out quality on a sliding scale – this is done by averaging data over small areas of the image, especially where there is no detail. Once compressed, quality is lost forever and artefacts may also be produced by compression.

☞ see Artefacts 31

THE KELVIN IS A MEASURE OF THE COLOUR TEMPERATURE OF
A LIGHT SOURCE. IT IS ONE OF THE BASE UNITS IN THE SI
SYSTEM OF MEASUREMENT. THE KELVIN SCALE, FIRST
PROPOSED IN 1848, IS A THERMODYNAMIC TEMPERATURE
SCALE STARTING AT ABSOLUTE ZERO. IT IS NAMED AFTER THE
PHYSICIST WILLIAM THOMSON, 1ST BARON KELVIN, WHOSE
STATUE IN GLASGOW'S KELVINGROVE IS SHOWN HERE.

☞ see Colour Temperature 70, White Balance 266

This is used to describe the overall tone of a photograph – more commonly for black-and-white portraiture although it can equally well relate to colour imagery. The key light or main light sets the character or the mood of an image. High-key refers to an image that is predominantly composed of lighter tones while low-key refers to an image composed largely of darker tones. This is not the same as under- and overexposure as both high- and low-key images still have a full tonal range. Pictured: flower photography in high-key and low-key style showing tonal bias.

High-key image Low-key image

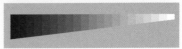

☞ see Exposure 108, Tone 251

The principal source of light in a portrait is the key or main light; the secondary source that fills the shadows with light is called a fill light. The key light dominates: it casts the most important shadows that model the face to reveal its three-dimensional qualities and sets the overall tonal key – determining whether it will be a dark picture or one full of light. How far the key light is placed from the subject depends on the type of light and the highlights it is required to create. The elevation of the light is usually judged by the length of shadow beneath the nose. If the key light is too high it will highlight the forehead in an unflattering way; too low and the lighting will look flat and shadowless, causing the sitter to screw up their eyes.

Finished portrait with key and fill light

Fill light off

Key light only

☞ see Fill Light 114, Key 148

In 1945, Edwin H Land (1909–1991) was already a successful businessman and research scientist, having founded the Polaroid Corporation on his development of a synthetic light-polarising material. On a trip, Land's young daughter asked why they could not see the pictures she'd taken straight away. Within a few hours, Land devised the necessary physical chemistry for instant photography and, by 1948, presented the world's first self-developing camera system. His SX-70 in 1972 was another world first – a fully automatic, motorised, folding SLR camera that ejected self-developing, self-timed colour prints. His instant movie system, however, was financially disastrous and he resigned from the Polaroid Corporation to pursue pure research, expanding his Retinex theory of vision.

Dr. Edwin H Land and Model 95 Polaroid Land camera, ca. 1947–1948.

Any image where the width is greater than the height,
irrespective of the aspect ratio. So-called because these
proportions better suit landscape subjects.

☞ see Aspect Ratio 32, Portrait Format 195

Dorothea Lange was born in 1895 in Hoboken, NJ, to German immigrant parents. She found it difficult to continue taking portraits of wealthy clients during the early years of the American Depression and turned to photographing the destitute. Her *White Angel Breadline* (San Francisco, 1933) is an early photograph in which she isolates one individual to represent the feelings and burdens of the many. By September 1935, she was working for the Resettlement Administration – later the Farm Security Administration – for which body she probably created her most powerful images, including *Migrant Mother* (Nipomo, California, 1936), now one of the world's most reproduced images. She excelled photographically where she had a cause. When she said: 'The camera is an instrument that teaches people how to see without a camera,' she was talking of social, not artistic, awareness. Lange died in 1965 shortly before her retrospective exhibition opened at New York's Museum of Modern Art.

Soper Grandmother, Who Lives With the Family, Willow Creek area. Malheur County, Oregon.

The leaf shutter is so-called because it opens and closes with hinged leaves of metal (unlike the focal plane shutter, which uses blinds). This means the whole image is seen as soon as the leaf shutter starts to open. The mechanism is usually found in between lens elements. Because of the method of its operation, flash synchronisation can occur at any shutter speed, which is welcomed by photographers who want to achieve fill flash on bright days but control and reduce the effect of the ambient light. Leaf shutters are usually found in lenses for medium- and large-format cameras.

☞ see Shutter 222

The lens is a transparent item, usually of glass, possibly plastic or even liquid, which focuses light by bending its rays. Being a denser medium than air, the lens slows the light as it enters the material of the lens at an angle. Positive curvature of a convex lens brings these bent rays together at the point of focus. Negative curvature of a diverging or concave lens bends the light away from the axis of the lens. Lens comes from the Latin word for 'lentil' because of its shape. Simple lenses show too many optical faults (aberrations) for photography, which needs compound lenses comprising elements and groups of elements, some of which are cemented together.

☞ see Focal Length 123

A lens hood or lens shade is a section of a cone or tube finished in matt black. It is used in front of the lens opening to cut out non-image-forming light as a source of lens flare. As the film and digital formats are rectangular, it is possible to shade the lens right down to the format shape; rectangular lens hoods or petal hoods (pictured here) are the most efficient. A lens hood lets the photographer work closer to a source of light without the reduced colour saturation produce by lens flare. They are particularly important if a filter is fitted to the front of the lens. Professional lens shades are in the form of adjustable bellows.

☞ see Flare 119

A light meter is used to measure the intensity of light for photography, giving a readout as a combination of shutter speed and aperture or a single Exposure Value (EV) number for a given film speed or digital sensitivity. Light meters can either measure the light falling on them (incident) or the light reflected from the subject (reflected). Additionally, they may measure only continuous light sources (ambient) or flash or both (flash and ambient). Light meter refers to all types of meters measuring light; exposure meters are those only concerned with giving a value for photographic exposure. A colour temperature meter is a light meter but not an exposure meter.

Digital light meters are so-called because they have a numeric readout and not a needle and scale. Modern meters can average multiple measurements and show exposure latitude.

☞ see Dynamic Range 100, EV (Exposure Value) 111, Spot Meter 235

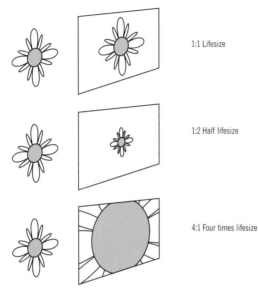

1:1 Lifesize

1:2 Half lifesize

4:1 Four times lifesize

Most subjects are recorded at less than one-seventh their actual size – expressed as 1:7 (the reproduction ratio). A photograph is considered to be a close-up if it is in the range one-seventh lifesize (1:7) to lifesize (1:1). True macro photography goes in further and is in the lifesize range (1:1), when the image of the subject and the subject itself are the same size, up to 20:1 where the image is 20 times larger than the subject – in other words it is magnified. Beyond 20 times lifesize are the realms of photography through a microscope, sometimes called microphotography but more correctly photomicrography.

Macro lenses are designed to give best optical performance at close distances (not with infinity subjects) and give lifesize reproduction as standard; a true macro lens is designed for best performance when the subject is closer to the lens than it is to the image plane.

☞ **see Bellows 40, Extension Tubes 112, Photomicrography 188**

It was said to be the effect on his health of the chemicals involved in the collodion process that first caused Dr Richard Leach Maddox (1816–1902) to look for an alternative. Collodion stuck to the glass plate and could be sensitised in a solution of silver nitrate but this had to be done shortly before a picture was made and the wet plate exposed in the camera. Leach Maddox experimented with a mixture of silver nitrate and cadmium bromide mixed with warm gelatin to coat glass plates, publishing his results in 1871 in the *British Journal of Photography*. However, it was not until ripening of the photographic emulsion was discovered (by others) that the gelatin emulsions on dry plates became sufficiently sensitive to displace collodion wet plates in the 1880s. Maddox is still credited with being the discoverer of the first practicable silver bromide gelatin emulsions on which almost all traditional photography is based.

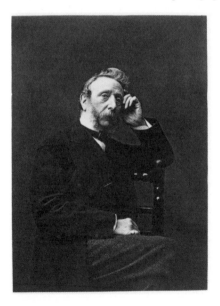

☞ **see Collodion Process 58**

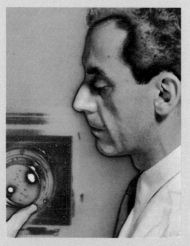

Autoportrait, 1931.

Man Ray (1890–1976), real name Emmanuel Radnitzky, was aligned with the surrealist movement and Dadaists. However, he is probably just best described – in terms of his photography – as a member of the avant-garde. Born in the USA, he moved to Paris in 1921 and spent much of his productive life there. Although he would probably have described himself as an artist or painter he was active as a fashion photographer and portraitist. Man Ray is strongly associated with the Sabattier effect, which he revived and perfected with his photographic assistant Lee Miller and with the photograms he named Rayographs after himself. His creative explorations remain influential.

☞ see Photogram 185, Sabattier Effect 211

Creating a colour image by adding red, green and blue colours in the correct proportions that they were reflected from the original image – additive synthesis – was first demonstrated by James Clerk Maxwell (1831–1879) in 1861. Most commercially successful colour systems have been based on subtractive synthesis, with negatives of cyan, magenta and yellow – the subtractive primary colours.

This colour image of a tartan ribbon was made by projecting three black-and-white positive images – each taken separately through a red, green or blue filter – on to a white screen using projectors fitted with the appropriate primary filter.

☞ see Additive Colour 21, Subtractive Colour 241

Metadata is 'data about data'. The header section of many image file formats contains data about the size and resolution of the file itself, the date and time the picture was taken and the camera settings (metering mode, exposure, whether flash was used, lens focal length, etc.). The format for much of this data has been standardised as the exchangeable image file format (EXIF). Adobe products, including Photoshop, use a metadata format known as the extensible metadata platform (XMP) standard. Metadata from other sources - including TIFF headers, GPS and IPTC information - is synchronised within XMP. International Press Telecommunications Council (IPTC) Photo metadata is related to copyright usage and image source. Global Positioning System (GPS) data gives longitude, latitude and possible elevation. Metadata can be exported or templated and is sometimes stored in a sidecar file rather than as header information.

see EXIF Data 107

Metamerism is the optical phenomenon where colours that seem to match under one light source change under another. Neutral images printed with a mix of colour inks are particularly affected – as shown, digitally simulated, in this image. What appears neutral in one light may appear magenta in another light and greenish-tinged under a third light source. Using true neutral inks is one solution, or printing to produce a neutral result for the illuminating light where the finished print will be hung.

Tungsten Fluorescent Daylight

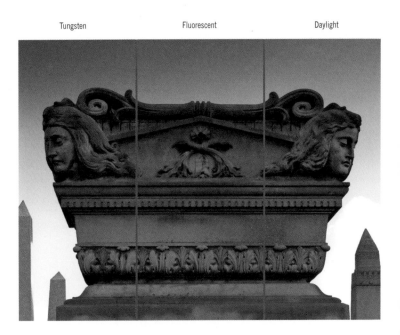

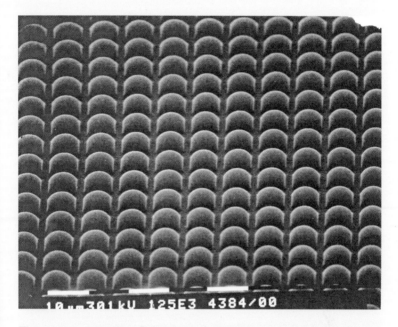

These are an array of tiny lenses that lie on top of the digital sensor to focus and direct the light into individual photosites. The photosites are like a row of buckets that all need illuminating head-on; light from an angle will never reach the bottom of the bucket and will not be detected. These lenses are moulded and can be progressively shaped to be more effective at catching otherwise wasted light from the angled rays towards the edges of the sensor.

☞ see Sensor 216

MIRED IS A MADE-UP WORD FROM MICRO RECIPROCAL DEGREES – IT IS PRONOUNCED 'MY-RED'. A MIRED EXPRESSES THE INVERSE COLOUR TEMPERATURE AND IS ONE MILLION DIVIDED BY THE COLOUR TEMPERATURE. THE INVERSE VALUE IS USED BECAUSE WHEN, FOR EXAMPLE, AN EQUAL BUT SMALL CHANGE IS APPLIED TO BOTH 3,000K AND 12,000K, WE PERCEIVE THE CHANGE TO 3,000K AS BEING MUCH LARGER. USING THE INVERSE COLOUR TEMPERATURE GIVES A NUMERICAL VALUE THAT NOW CORRESPONDS TO THE PERCEIVED CHANGE AT ANY COLOUR TEMPERATURE.

THE MIRED IS A COMMONLY USED TRADITIONAL UNIT WHEN CONVERTING FROM ONE COLOUR TEMPERATURE TO ANOTHER WITH FILTERS – OFTEN REFERRED TO AS MIRED SHIFT. THE EXPRESSION RECIPROCAL MEGA KELVIN MK^{-1} (READ AS 'PER MEGA KELVIN') IS NOW BEGINNING TO BE USED AS IT IS BASED ON THE SI SYSTEM OF UNITS.

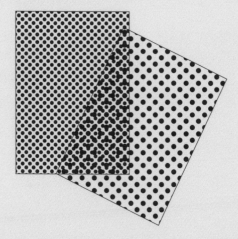

A moiré pattern is the shimmering interference effect you see when the wind blows a net curtain and parts of the mesh fabric overlap at an angle. In digital photography an image is sampled at regular intervals, which means the simple sampling process can interfere with repeating patterns on the subject – some fabrics or textures will create a 'beating' pattern with the pixels of the image sensor. The interference effect is inherent in the sampling process but can be reduced with some image processing software. It is a type of aliasing.

In book and magazine printing, each of the four coloured inks (cyan, magenta, yellow and black) is laid down with a regular screen of variable-sized dots. The angles at which these screens overlap is vital in giving the appearance of a continuous, smooth-tone colour image. Print professionals sometimes refer to moiré as 'screen-clash'. Scanning a magazine or book image will create another interference pattern and many scanner software drivers offer a de-screening option to minimise the unsightly patterning.

☞ see Aliasing and Anti-aliasing 24

Monochrome literally means 'one colour'. While that 'colour' is usually presumed to be black – a monochrome photograph being synonymous with black-and-white, as shown here – this need not always be the case. A monochrome image can theoretically consist of any of the possible shades of any single colour. A brown monochrome image would show the image in shades of light to dark brown. Browns, blues and greens do a good job as monochrome images, the solid colours having sufficient density. Colours that are perceived as being lighter, such as yellow, do not work well to produce monochrome images as they cannot show a full tonal range.

see Duotone 97

A single-legged camera support, which is more convenient to transport than a tripod. Used by professional photographers the world over, they offer support in one dimension only and require some skill in steadying the camera to be of great advantage. Monopods are sometimes equipped with a foot stand for extra stability or built into hiking poles for photographers who want to pack as little equipment as possible when walking or climbing.

It is much easier to follow the action with a monopod and they are often used at sporting events, as shown, or in the field, with long-focus lenses to avoid blurred images from camera shake.

☛ see Tripod 254

In a conventional camera, lens and image planes are in a fixed parallel relationship. This means the plane of focus will be always parallel to the camera back. With a view camera, both image plane (the film back) and lens plane can be adjusted with three degrees of freedom. This allows almost complete control over the shape of the subject, as it appears in the image, the plane of focus and depth of field. View camera lenses produce large, circular images, much bigger than the film format used. Lens and film back can be moved relative to each other without loss of image but excessive camera movements may produce poor definition.

To control shape	swing or tilt the back
To control sharpness	swing or tilt the lens and/or the back
To control both shape and sharpness	swing or tilt the back for shape; swing or tilt the lens for sharpness
To obtain overall sharp focus	the plane of the subject, the plane of the lens (board) and the image plane (film) must either be parallel or meet at a common point (Scheimpflug rule).

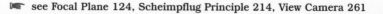see Focal Plane 124, Scheimpflug Principle 214, View Camera 261

Rise, fall and shift are all parallel movements that move the lens up, down and sideways, relative to the centre of the camera back.

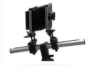

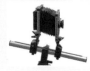

Camera zeroed (no movements applied) top and side view

Correct converging verticals

Controlling shape of box

Maximise sharpness throughout landscape image

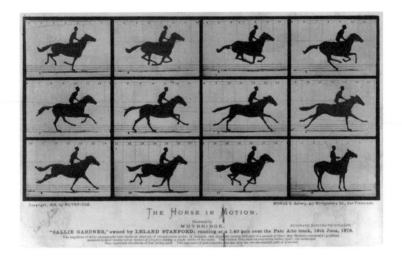

In 1877 this British photographer, then working in America, settled the age-old dispute as to whether a horse has all four feet off the ground when galloping (they do) by using a series of successively triggered cameras. Muybridge (1830–1904) developed his technique to look at all forms of animal and human locomotion. These sequences were later published for use by artists and designers. Muybridge produced a projector – based on the children's toy zoopraxiscope – for his sequences, establishing the basis for the movie industry once roll-film technology was sufficiently advanced. He had a complex personal life and gained only little credit for his work during his lifetime.

The first images on light-sensitive material showed inversion of the expected tones. As the materials all went dark where light fell on them, they showed black where the subject was white. In the late 1830s, William Henry Fox Talbot was first to understand and perfect the making of positive prints from an original exposed image. Sir John Herschel gave these the names 'negative' and 'positive'. The importance of Fox Talbot's work was not just that a photographic image could be produced but that the negative/positive system promised many copies from one original.

In the now familiar black-and-white film negatives, tones are reversed and black becomes white, as seen in this contemporary negative and darkroom print of a derelict farm off Route 14 in NY State, USA. In colour negatives, colours are reversed – in fact they are the opposite colours across the colour wheel from those seen in the subject.

☞ see Calotype 47, Colour and the Colour Wheel 60, Photography 186

A neutral density (ND) filter reduces light intensity equally across the spectrum. It can be used to adjust exposure when it is not desirable or not possible to change the lens aperture – as with some reflex (mirror) lenses). ND filters let the photographer use a wider aperture than might otherwise be possible, permitting shallow depth-of-field images to be created outdoors on bright days. Conversely, an ND filter can be used for longer exposure times. The classic shots of moving water that appear misty or milky are often produced in this way.

Some manufacturers specify filters as ND-2, ND-4 and ND-8, which pass one-half, one-quarter and one-eighth the light: 1, 2 and 3 stops reduction respectively. Other manufacturers use the density 0.3, 0.6, and 0.9 descriptions for these same filters. Graduated ND filters are used to control excessive scene dynamic range.

Neutral Density Filter

☞ see Graduated Filter 134

Newton's rings from glass in negative carrier

First described by the 'father of microscopy' Robert Hooke in the 1660s but named for physicist Sir Isaac Newton, Newton's Rings are an optical phenomenon. They are an interference pattern that occurs when light is reflected between a flat and a curved surface. This can happen in some enlargers when the slightly curved film comes into contact with the flat glass of some negative carriers. A distinctive light-and-dark pattern of 'ripples' is produced, spoiling the finished print. Any darkroom worker knows how difficult it can be to get rid of Newton's Rings. Some enlargers can be fitted with anti-reflective glass – sometimes called anti-Newton glass – which has a micro-fine texture to break up the reflections that cause this phenomenon.

☞ see Enlargement 105

Written on the mount of the image shown are the words: 'Monsieur Niépce's first successful experiment of fixing permanently the Image from Nature'. Joseph Nicéphore Niépce (1765–1833) can be credited with producing the first permanent photographic image in about 1826. His almost day-long exposure from an upper window in his house in Chalon-sur-Saône was made in a camera obscura using a photosensitised plate of lead alloy coated with Bitumen of Judea, which hardens in light. He was able to wash away the unhardened areas with a mixture of petrol and lavender oil to leave a direct positive image he called a heliograph (sun drawing).

View from the Window at Le Gras – in the commonly reproduced, much-retouched and enhanced version shown here – was not discovered until the 1950s. The original is in the Helmut and Alison Gernsheim collection at the University of Texas in Austin.

☞ see Camera 48

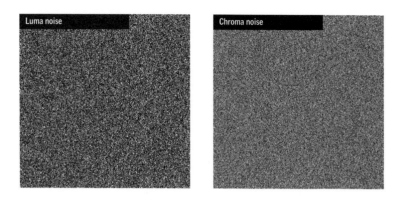

Noise is to digital photography as grain is to film. Digital noise is best described as 'pixels out of place' in the regular pattern of the pixel mosaic. It appears as black-and-white pixels (Luma noise) or as colour pixels (Chroma noise). Digital noise can be produced when using high ISO sensitivity settings or with long exposures. Some cameras feature long-exposure noise-reduction settings to reduce this latter effect.

While grain can be considered a positive feature of film photography – something to exploit artistically – the same cannot be said for digital noise. For this reason, most digital photographers are interested in reducing noise, which can be done in-camera, handled at the conversion stage with Raw files, or later, using dedicated noise-reduction software.

☞ see Grain 135

N Northlight

erpt.

This photograph of photographer Monika Ueffinger was taken by the author in a temporary studio set-up to catch bright afternoon light from a north-facing window.

Northlight (northern hemisphere only) is the bright but diffuse light from a north-facing window, i.e. one that is not lit by direct daylight but by the bright sky. It is a very attractive light to use for portraiture and many portrait photographers once built north-facing studios in order to take natural light 'northlight' portraits. In the modern studio, the 'northlight' is an area light or softbox to imitate this look. The studio lamps are diffuse light sources similar in effect to indirect daylight from a window.

This is a recognised form of product photography using simple top or frontal lighting and is usually a form of tabletop photography. 'Pack' shot is shorthand for packaging shot, which is a product image used for commercial or advertising purposes. Cameras offering swings and tilts will be used to control the shape and perspective of the product in the image. Great care is taken with lighting to create the best possible look for the product.

Specialist pack shot studios produce nothing else and may work on a repetitive production line approach. A standard lighting arrangement will be fine-tuned for each product, especially when photographing variations of a product or product range for catalogues.

It is possible to use a moving light source such as a hand torch to paint the subject with light in a darkened room. Digital cameras make it easy to experiment with this technique. Either the B (Bulb) setting can be used for an open shutter and the exposure estimated or the camera can be set to Aperture Priority (A or AV).

The image here of a 'cabinet of curiosities' was taken with the aperture set to f/27 and the camera automation made the exposure 30 seconds, giving adequate time to move the torch in close to the objects. The interiors of large buildings can also be illuminated in this way using a series of flash exposures.

☞ see Aperture Priority 28, Bulb 44, Time Exposure 249

Chapter 13: Where our heroes discover they can hire five boats not six.
This contemporary palladium print of gondolas on a Venice lagoon is from a conventional 5x4 negative.

Palladium prints were originally suggested in the late 19th century as an alternative to silver gelatin papers. These now-alternative darkroom processes use the metals platinum and palladium in place of silver as the photosensitive salt. There is no commercially available paper and those who work with the 'Platino-Palladiotype' (Pt/Pd) process prepare their own printing paper from raw chemicals and fine art paper. The attraction is the archival permanence of these prints and their subtle tonal range. The metal salts (Ammonium Tetrachloroplatinate and Ammonium Tetrachloropalladate) can be used separately or together to produce rich browns through slate grey and neutrals to a blue-black image. Exposure is usually contact printing from a negative in strong UV light.

🖝 see Alternative Processes 25

Panning is a technique to make a moving subject appear stationary. It has the added advantage of blurring background detail, which focuses attention on the subject and creates the illusion of speed and movement within the image. By moving the camera smoothly and in synchrony with the subject, the camera–subject relationship is fixed for the length of the exposure – which is why the car in this image appears in crisp detail. The fact that the car is moving at a fair speed is clear from the degree of blur in the background. Panning requires a steady hand, a monopod support or use of the panning head on a tripod and 'follow-through' after the exposure is made, for best results. Surprisingly long shutter speeds can give good results and the longer the shutter speed, the more blur in the wheels.

The MG Metro 6R4 belonging to rally driver John Bogie of Dumfries, Scotland.

☞ see Monopod 167, Tripod 254

A PANORAMA IS A WIDE, UNBROKEN VIEW. FOR A
PICTURE TO BE CONSIDERED PANORAMIC IT SHOULD
MATCH OR EXCEED THE NATURAL ANGLE OF HUMAN
VISION. FULL 360° PANORAMAS CAN BE PRODUCED.
PANORAMAS CAN BE MADE WITH A PANORAMIC
CAMERA OR FROM A SEQUENCE OF IMAGES USING
STITCHING SOFTWARE. STITCHED PANORAMAS CAN
BE MADE FROM THE INDIVIDUAL IMAGES IN ONE OF TWO
WAYS: PERSPECTIVE OR CYLINDRICAL MAPPING.
PERSPECTIVE MAPPING TRIES TO CREATE A TRUE
PERSPECTIVE VIEW BY DISTORTING AND STRETCHING
IMAGES TOWARDS THE EDGE OF THE COMPOSITION,
CREATING A 'BOW-TIE' IMAGE AS SHOWN HERE.
CYLINDRICAL MAPPING IS AS IF EACH IMAGE WERE
PASTED IN MATCHING SEQUENCE ON THE INSIDE OF
A LARGE TUBE.

☞ see Panoramic Camera 182, Stitching 238

A CAMERA CAPABLE OF TAKING A PANORAMIC VIEW. THE SIMPLEST PANORAMIC CAMERA IS ONE WHERE A WIDE-ANGLE LENS IS MATCHED WITH A FILM FORMAT HAVING A WIDE-ASPECT RATIO — THESE ARE SOMETIMES CALLED WIDE-VIEW OR WIDE-FIELD CAMERAS. THE ALTERNATIVE WAYS OF MAKING A PANORAMIC IMAGE ARE TO SWEEP THE IMAGE ACROSS THE FILM — AS DONE IN A SWING-LENS CAMERA — OR TO ROTATE THE WHOLE CAMERA WHILE THE FILM IS DRIVEN THROUGH THE CAMERA, IMAGING THE CHANGING VIEW AS IT GOES. THE FIELD OF VIEW OF A SWING-LENS CAMERA IS PHYSICALLY LIMITED TO LESS THAN 180°; THE ROTATING CAMERA CAN COVER THE FULL 360°.

A Noblex 135U, which produces a horizontal 127° view on 35mm film as shown, and features a rotating lens with a constant shutter slit on a curved film plane.

☞ see Panorama 181

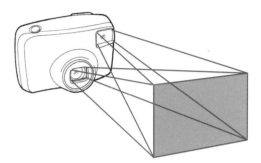

With distant subjects, the viewfinder and lens frame the same view.

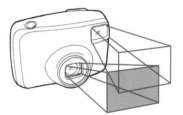

As the subject comes closer the lens and viewfinder frame different views.

This may occur in a camera system where separate optical systems are used for viewing and for picture taking: Twin Lens Reflex (TLR) cameras and viewfinder cameras, for example. For distant objects, the difference in location between the two is practically irrelevant. As the subject comes closer, the viewfinder for framing and the taking lens 'see' quite different views, making it difficult to get the subject in the frame. Some cameras feature parallax compensation with a viewfinder that moves as the lens is focused closer. Others feature a second frame for close focusing; one TLR manufacturer supplied a lift/lower device (the Paramender) to swap the position of the viewing and taking lenses to overcome this problem.

Long focal-length lenses seem to compress depth, known as shallow perspective (top), while wide-angle lenses give the opposite effect, sometimes referred to as exaggerated perspective (bottom).

Perspective is the means by which we interpret three-dimensional space in a two-dimensional image. In photography, perspective is conveyed by diminution in scale, overlapping shapes and lines receding to a point in the distance (linear perspective) and by changes in colour where closer objects appear darker (aerial or colour perspective). The choice of viewpoint and lens focal length plays a major part in the representation of perspective depth in a photograph.

☞ see Aerial Perspective 22, Viewpoint 263

Rayographie 'Sans titre' (spirale), 1923.

'Rayographs' or 'Rayograms' are photograms produced by Man Ray.

The photogram is the simplest form of photographic imagery. It is created by the shadows cast by an object when in close contact with the photosensitive material that is subsequently processed or developed. No lenses or pinholes are involved in projecting an image (a chemigram uses just photographic chemicals). The simplest photograms are just shadows, like the sun print pictures of hands made by schoolchildren. The translucency and reflective nature of the object may also be seen in reflective flares and ghostly shadows. Although a simple technique, its very simplicity appeals to many. The so-called Rayographs/Rayograms and Schadograms are photograms produced by the artist **Man Ray** and painter **Christian Schad** respectively.

☞ see Cyanotype 80, Man Ray 159

Originally there was no one accepted word for the act of creating permanent images with light: pioneer Joseph Nicéphore Niépce, for example, referred to his images as heliographs; William Henry Fox Talbot called his photogenic drawings. Sir John Herschel coined the word 'photography' in 1839 – the year photography was announced to the public and scientific communities in both England and France. It is a compound of the classical Greek words for light and the act of drawing or writing: *photos* and *graphien*. Herschel also applied the words we still use, 'negative' and 'positive', to Fox Talbot's process.

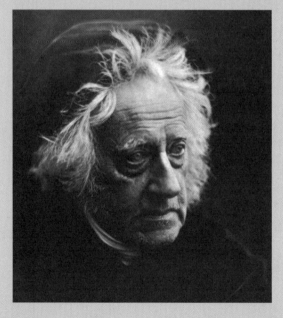

A portrait of Sir John Herschel, the British astronomer royal, taken in 1867 by Julia Margaret Cameron.

see Fixer 118, Negative/Positive 171

Photojournalism is newsgathering using images rather than the written word. Photojournalism is intentioned photography with an element of timeliness and presumed objectivity. An image will aim to tell a story and may well be part of a longer narrative photo essay.

A photomicrograph is an image taken through a light microscope with a camera – sometime referred to as photomicroscopy. This produces a magnified image of an item. Magnification above x20 is usually considered the point at which macro or close-up photography becomes photomicrography. Illumination can be with any of the common techniques used by the microscopist – transmitted, dark-field illumination or incident light – as the camera simply records what is on the microscope stage.

Pictured here are paracetamol crystals in polarised light x40 imaged with a Kodak Professional DSC 520 (Canon mount) on a Brunel BMS trinocular zoom stereomicroscope.

☞ see Bellows 40, Macro Photography 157

Adobe's Photoshop is now so familiar as the industry standard image-editing software it is taken for granted that it has always been around. In 1987 it was a piece of software to display greyscale images on black-and-white monitors called Display. Its writer was Thomas Knoll. His brother John, who worked for Industrial Light and Magic, the special effects division of Lucasfilm, helped re-write Display to work on the new colour Macintosh II.

But although features were developed, no company wanted to buy or promote the software until the brothers agreed to bundle Photoshop Version 0.87, as it was called by then, with Barneyscan scanners. Soon after seeing the product in demonstration, Adobe agreed to buy a licence to distribute. Adobe did not actually buy Photoshop until it was already a well-developed and successful product – and the rest is history.

A photographic movement of the late 19th century that had ended by the early years of the 1914–18 war. The movement stressed aesthetics, the beauty of the image, and was driven by a desire to emulate fine-art painting. Soft-focus lenses, platinum printing and darkroom manipulation created an imagery that at best recalled impressionism and at worst was merely picturesque. Although originally a British movement, it heavily influenced American Alfred Stieglitz who promoted pictorialism through his gallery and magazine *Camera Work*.

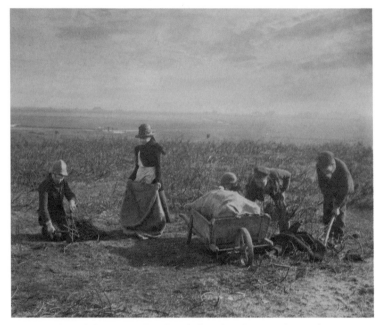

Pictorial platinum print *Furze Cutting* by Peter Henry Emerson, who created a pastoral idyll in his search for a 'naturalistic' photography.

☞ see Stieglitz, Alfred 237

Pinhole photography uses a pinhole instead of an image-forming lens capable of being focused. A tiny hole produces an image by restricting possible light paths from brightly lit points on the subject to just one. A coherent, upside-down image can be projected inside a camera by a pinhole and there is no concept of focusing; the further away the pinhole is from the film or sensor, the bigger and dimmer the image. The pinhole image is effectively made up of tiny overlapping circles. The images projected by pinholes are much dimmer than those focused by lenses and so pinhole cameras require much longer exposure times.

☞ see Alternative Processes 25, Time Exposure 249

There are disagreements about whether the made-up word 'pixel' was a contraction of Picture Element or Picture Cell. Either makes a good definition. The pixel is the result of digital sampling and records the numerical data for the colour found at that location in the image. Pixels are not units and are not comparable from digital camera system to system as they have different sizes and, sometimes, different shapes. One million pixels are a megapixel (Mpx).

Given sufficient pixels in an image they cannot be seen, but if a digital image is over-enlarged and the pixels become visible, it is said to be 'pixellated'. Shown (right) is an enlarged section of a 50x50 pixel area from a 4Mpx original image (above).

☞ see Colour Filter Array 64, DPI/PPI 96, Sensor 216

As mentioned in the entry for diffuse lighting, there are really only two types of light needed to create the full range of photographic lighting: the spotlight and the floodlight. The spotlight – or even a bare bulb or the sun itself – creates a harsh, high-contrast light. This is quite unlike the soft light from a floodlight or diffuse light source, which is light from a single source smaller than the subject.

Compare this image with the image on page 89 to see the difference. Note the bright, crisp quality to the highlights on the pencils and even on the corner of the wooden pencil holder, the distinct shadows and the strong wood texture.

☞ see Diffuse Lighting 89

Polarising filters work with the physical characteristics of light, not colour. They are used to control reflections from non-metallic surfaces and to darken skies at 90 degrees to the sun. Light waves reflecting from a smooth surface tend to be oriented in the plane of that surface. The polarising filter has a molecular or crystal structure that lets light through at only one angle. It can be rotated to block most of that reflected light. Neutral in colour, polarising filters have some effect on contrast and colour saturation and work equally well with colour, black-and-white film or digital. Linear polarisers are used with large- and medium-format cameras, manual viewfinder/rangefinder and SLR cameras. Circular Polarisers (C-Pol) work with modern cameras that have autofocus, but are more expensive to buy than simple linear filters.

Without polarising filter

With polarising filter

Any image where the height is greater than the width,
irrespective of the aspect ratio. So-called because these
proportions better suit head and shoulders portraits.

☞ see Aspect Ratio 32, Landscape Format 151

A prime lens is a camera lens of a single, fixed focal length, in contrast to the variable-focal-length zoom lens. The advantages of the prime lens over the zoom lens are simpler optical design and construction, which may mean a higher resolution image with less distortion. Additionally, they can be designed with high maximum apertures and have better light-gathering qualities. Prime lenses usually have a more pleasant bokeh than zooms and far less complex flare characteristics when they are used close to a light source. It is more common to find a useful depth-of-field scale on a prime lens.

A Leica 100mm apochromatically corrected macro lens offering extremely low geometric and colour distortion and high-detail resolution.

☞ see Bokeh 41, Flare 119

You do not have to expose film at the manufacturer's recommended speed.

Push processing is done when you have pushed the speed up, exposing an ISO 400-rated film at an Exposure Index (EI) of 1,600 (to work in low light without flash). The film is effectively 2 stops underexposed and it must be overdeveloped to compensate. This results in increased contrast and grain.

Pull processing is done when you have pulled the speed down by exposing an ISO 400-rated film at an Exposure Index (EI) of 320 (to reduce grain). The film is effectively 1/3 stop overexposed and it must be underdeveloped to compensate. This results in lower contrast and grain.

A RANGEFINDER CAMERA HAS AN OPTICAL VIEWFINDER BUT, UNLIKE A SIMPLE VIEWFINDER, WHICH IS USED SIMPLY TO FRAME THE SUBJECT, IT PROVIDES SOME MEANS OF FOCUSING THE CAMERA. RANGEFINDERS WORK WELL IN LOW-LIGHT SITUATIONS BUT NEED ADEQUATE SEPARATION BETWEEN THE TWO VIEWFINDER WINDOWS TO OFFER GOOD DISCRIMINATION.

Rangefinders – like this Leica M6 – commonly use a split-image system where an image is projected from a second viewfinder window as a virtual image into the first. The lens and rangefinder mechanism are coupled and adjusted so that when the two images coincide, the lens is in focus. The frosted window on this camera is used to illuminate the frame lines for its interchangeable lenses.

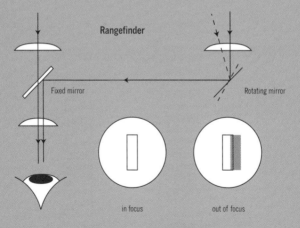

Rangefinder

Fixed mirror

Rotating mirror

in focus

out of focus

☞ see Viewfinder Camera 262

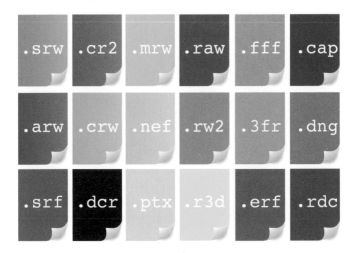

Each camera manufacturer employs a proprietary file system. These are some of the
many Raw file extensions.

Camera-raw or raw-format files come straight from
the digital camera sensor without first being
processed by the camera. Raw files feature 12-bit
resolution; the benefit is that further processing
by computer gives latitude in exposure and white
balance and some degree of future-proofing.

Raw files from long-discontinued camera systems can
still benefit from the latest advances in Raw file
decoding and manipulation. Adobe Systems proposed
an open standard for camera Raw files in their
digital negative (DNG) format, which has been
adopted by only a few manufacturers.

The law of reciprocity is the key to photographic
exposure. It states: the density of the image formed
is in direct proportion to the intensity of light and its
duration. For a given sensitivity, exposure is the
balance between duration (shutter speed) and
intensity (lens aperture). To maintain a constant
quality of image, duration needs to keep a reciprocal
relationship with intensity. If you open the aperture
to increase the intensity, then you must reduce the
duration. Conversely, if you reduce intensity by making
the aperture smaller, duration must be increased to
keep the same exposure.

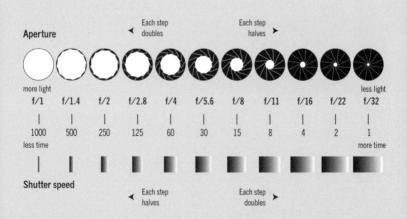

This box of Fuji colour reversal film shows no change in effective sensitivity even with a long, 32-second exposure but at this shutter speed a 2.5M (magenta) colour correction filter is recommended.

The law of reciprocity can break down with extremely long or short duration exposures or with extreme light intensities. Extra exposure may be required to achieve a good exposure than that predicted by the normal linear relationship. With colour materials, the colour fidelity may shift and some correction may be required – this is usually done with colour correction (CC) filters. Film manufacturers add a notification on the packaging outlining the conditions in which reciprocity breaks down with their product and what adjustment is required.

☞ see Colour Correction Filters 63, Reciprocity 200

In flash photographs, the subject's eyes may sometimes seem to glow red. This is caused by the source of the flash being close to the camera lens. Light from the flash travels through the lens in the subject's eyes and illuminates their interior; the camera picks this up because of the shallow angle between the lens and the flash. The blood-rich human retina shows up red. The best solution is to move the flash away from the camera lens, but as consumers demand compact cameras where lens and flash must be close together, this is not always possible.

Red eye

Red-eye reduced

Software solutions are nowadays used, which identify red eye and correct it by making just these pixels darker. The phenomenon occurs with animals but their retinas reflect differently, like the blue of this calf's eyes.

No reflector

Gold reflector

A reflector is any object that reflects much of the light falling on it. Reflectors are most often used to reduce the shadow effect of a main light source by reflecting light back into the shadowed area of the subject. White card, even newspapers, can be used as reflectors but photographers often use collapsible reflectors made of fabric stretched over a thin metal hoop. These usually offer white-, silver- or gold-coloured reflective surfaces; some offer a choice in zip-over covers. A white side offers a neutral light; a silver side offers a cool reflection, while a gold surface produces a warm reflection – often called the 'instant sun tan' – for portrait photography.

☞ see Fill Light 114

A Swedish art photographer, Rejlander (c. 1813–1875) set up a portrait studio in Wolverhampton, England, and began experimenting with large-scale combination prints made up from individually photographed sections. His best-known allegorical piece, *The Two Ways of Life*, dates from 1857. This massive work (comprising over 30 separate images) was initially considered indecent. It depicts a father figure showing his two sons the moral life contrasted with that of a debauchee. It was the nudity that caused offence, although Queen Victoria's buying a copy for Prince Albert helped assuage public objection. Rejlander also used staged photography as shown in this extraordinary image, which needs little analysis beyond explaining that the object is a hoop cage from a woman's crinoline skirt.

The Bachelor's Dream, 1860.

This sort of lighting is named for the seventeenth-century Dutch artist, Rembrandt Harmenszoon van Rijn: one of his many self-portraits is shown here with the distinctive patch of light on his left cheek that photographers sometimes refer to as 'a Rembrandt'.

In Rembrandt lighting, the face is lit by single main light to one side, which creates a triangle of light on the far cheek. Rembrandt lighting unusually lights the narrow/short side of the face, the side of the face turned away from the camera. Light fills this side of the face, spilling over the nose to catch the cheekbone and cheek on the broad side of the face, which creates the 'Rembrandt' triangle. Without a fill light, Rembrandt lighting is highly dramatic, high-contrast lighting. Rembrandt lighting is sometimes referred to as 'Old Master' lighting.

☞ see Broad and Short Lighting 43, Fill Light 114, Key Light 149

When colours cannot be captured by a specific colour space, they are said to be 'out of gamut'. Rendering intent is a way of dealing with these out-of-range colours when converting from one colour space to another. The difference is how the colour management system handles this conversion. The International Colour Consortium (ICC) specifies four rendering intents: these are the options you see when you select colour conversion options, set soft-proofing, or go to print in Photoshop and in similar image-editing software.

Absolute colorimetric does not change the colours inside the destination gamut. Out-of-gamut colours are clipped and there is no scaling of colours to destination white point. The aim is to keep colour accuracy at the expense of relationships between colours. This intent is for proofing, to simulate the output of a particular device and is useful for seeing how paper colour affects printed output.

Relative colorimetric compares the whitest value of the source colour space to that of the destination colour space and moves all colours accordingly. The values of out-of-gamut colours are changed to that of the closest colour that can be reproduced. Relative colorimetric rendering intent saves more of the original colours in an image than perceptual rendering.

Perceptual tries to keep the relationship between the colours as the human eye perceives it, even though the colour values may all change slightly. Perceptual rendering intent is best for photographic images with lots of out-of-gamut colours.

Saturation produces vivid colours at the cost of accuracy. This rendering intent is best suited to business graphics where bright, saturated colours are more important than the exact relationship between colours.

☞ see Colour Space 69

Rim lighting is a specific form of backlighting, where the light comes around the edge of a subject from a concealed light source behind or to the side of the subject. At its most intense, this produces a key line around the silhouetted subject. A rim light can be used with front lighting to create an attractive glowing halo of light around an apparently normally lit subject.

see Backlighting 37, Silhouette 226

Ring
flash is a circular flash
unit that fits around the camera lens
to give even, shadow-free axial lighting.
Used in portraiture and fashion photography,
large ring flashes – either a fully circular flash tube
or a large ring diffuser – give distinctive flat lighting,
with a giveaway doughnut-shaped catchlight in the eyes.
The smaller ring-flash units that are made up of
independently powered segments – or even three
or four separate flash heads – allow some control of
directional light to model the subject. These are
more often known as macro lights as they are
better suited to close-up photography than
to portraiture, which requires
a much larger light
source.

☞ see Catchlight 52, Macro Photography 157

Roll film is the generic name for any photographic film supplied on a
spool with a paper backing. Many formats have long since gone but
120 roll film still enjoys wide usage. This film is 6cm wide and can
be used in a range of cameras and film-backs to produce a variety of
image sizes on the length of film, depending on the format chosen.
For example, 645 (6x4.5cm), 6cm square (sometimes still called 2 1/4
square) and 6x7cm (the so-called 'ideal' format) images can all be
shot on the same type of roll film. Images as wide as 17cm can be
taken on some cameras. Photography on 120 roll film is commonly
referred to as medium-format (MF) photography.

☞ see Aspect Ratio 32, Format 127

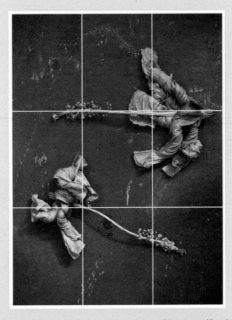

Geometric aids are often more useful for cropping at image-editing stage, although they can be
used quite deliberately for object placement in studio still-life images, as shown here.

This is a compositional device based on the
idea that the centre of interest in an image
can be placed at the intersection of lines
that divide up the image frame into thirds.
It establishes some compositional structure
in an image but there are alternative, equally
valid, placements using Golden Number
divisions or Dynamic Symmetry, which use
diagonals rather than a grid.

 see Composition 72

The Sabattier Effect is the tonal reversal, as shown in this Man Ray image, caused by exposing the print to light partway through development. Dark areas appear to be light and light areas are darkened. Man Ray is associated with this technique, which was first stumbled on by his then darkroom technician Lee Miller. It is sometimes incorrectly referred to as solarisation and is more accurately described as pseudo-solarisation. True solarisation is the effect of massive overexposure on a negative: Ansel Adams's famous print *Black Sun* shows the effect of complete tone reversal on the solar disc. Computer filters now imitate the effect.

Man Ray's *sans titre (nu masculin solarisé)*, 1933.

☛ see Man Ray 159

The photographic emulsions on black-and-white printing paper are sensitive to blue and green light only. As they are not fogged by exposure to red light, red lamps can be used to illuminate darkrooms. This lets the photographer work in something other than complete darkness. Some modern safelights can be designed to operate with a very narrow waveband and produce a bright – to our eyes – yellow light.

Above: a classic orange-red safelight. Right: a darkroom lit by this light. Compare this darkroom with the one seen in white light on page 83.

☞ see Darkroom 83

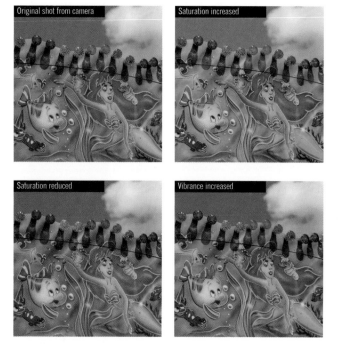

Saturation is strength of colour. The saturation slider will increase the saturation of all colours and will clip colours that are already saturated. The more recently introduced concept of Vibrance allows the user to adjust only the colours that are unsaturated, avoiding clipping already saturated colours. Black, white and grey have no colour saturation.

☞ see Clipping 57

To obtain overall sharp focus, the plane of the subject,
the plane of the lens and the image plane (film or sensor)
must either be parallel or meet at a common point.
Most photographers are familiar with the first part
of this statement as their cameras fix lens and image
planes in parallel. The plane of focus then falls parallel
to this through the subject. The second part about
'meeting at a common point' relates to cameras where
lens plane and image plane can be adjusted (view
cameras or tilt/shift lenses). This is the Scheimpflug
principle and it is used when setting up a view camera
to maximise depth of field along the subject plane.

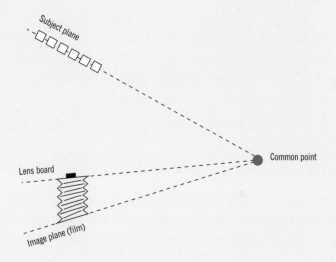

see Focal Plane 124, Movement 168, View Camera 261

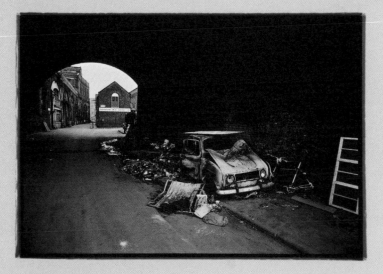

Stronger concentrations of selenium toner produce a noticeably purple cast to the grey tones,
as in the toned image printed on warmtone paper reproduced here.

Selenium toner changes some of the silver in the
photographic print to silver selenide. At low concentrations,
selenium toner produces archival toning with little visible
effect on the image, though greys may look a little more
graphite. Selenium toning may produce a slight increase in
image density. Over-long immersion or too strong a solution
of toner produces an aubergine (egg-plant) colour that is not
always pleasant to look at. Selenium can be used to tone the
darker parts of an image only, leaving the highlights to be
toned brown by a sulphide toner.

 see Split Tone 234, Toning 253

Any device that measures some quality and converts it into a signal for recording. The sensor in a digital camera, sometimes referred to as the digital 'chip', is a light-sensitive monochrome analogue device measuring the light intensity across an array of photosites. Red, green and blue filters printed on an overlay give three values that can be used to record the colour of the light for any pixel. The digital part of the process is the sampling across a regular array and the encoding and storing of a number code for the RGB values. Sensors are rated by the number of pixels they record, with 8-12 megapixel (Mpx) chips now in common use and up to 60Mpx sensors employed in some professional digital cameras.

☞ see Colour Filter Array 64, Digital Photography 91

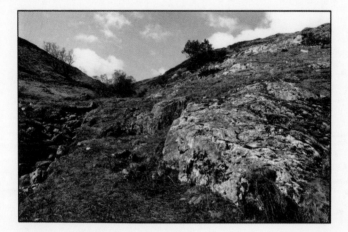

Unlike some toning processes, sepia is not archival. Sepia toning is a two-part process to change the fundamental chemistry of the silver halide print. The black silver image is first bleached back and then redeveloped in a toner that produces brown silver sulphide. If the image is completely bleached, an all-brown sepia print will be produced like the landscape image pictured. If the bleach is only allowed to work on the light tones near the highlights in the print, then after toning the print will show brown highlights and black shadows. This is sometimes incorrectly described as 'split toned'; more correctly it should be described as 'partially toned'.

☞ see Split Tone 234, Toning 253

Shadows are the dark areas in an image. In a five-stop image, the shadows are considered to be the lowest tonal values below the highlights, three-quarter tones, mid-tones and quarter-tones. In some image-editing software, the tone curve is only divided into four regions; the tones lying in the bottom quarter are considered shadow tones. As shadow tones in digital images have the fewest levels in their encoding, they are more susceptible to noise during image enhancement and manipulation.

The shadow areas in a conventional landscape image using blue as a false colour (below); original image (left).

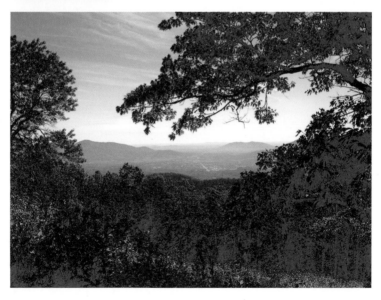

☞ see Highlight 138, Histogram 139

Sharpness is a subjective term combining the ideas of resolution (amount of detail) and acutance. A sharp image is one that is clean, crisp and finely detailed. The main causes of an image not being sharp are: camera shake, poor focus and possibly using too small a lens aperture (diffraction effect). The ideal strategy is to get as sharp an image as possible from the camera. Post-camera sharpening then needs to be applied. With film, this may involve choice of developer and good darkroom practice with critical focus on the enlarger and flatness of the negative and paper. All digital images and scans need sharpening in stages: first for capture, possibly locally for creative effects and final sharpening for a specific output medium. Sharpening works by increasing local contrast along edge detail.

From camera/ Capture sharpening Creative sharpening Sharpened for output
unsharpened

see **Acutance 19, Diffraction Effect 89, Unsharp Masking 259**

Miniature- and medium-format images are produced in multiples on lengths of film backed by paper or in cassettes. In contrast, large-format photography uses individual sheets of film, each with one image, much as it was in the days of glass plates. Sheet film can still be bought in various sizes: imperial sizes 5x4in, 5x7in and 10x8in are common. Smaller, discontinued sheet sizes or those based on the old whole plate size (6 $\frac{1}{2}$ x 8 $\frac{1}{2}$ in) can be cut out of larger sheets in the darkroom. Supplied in boxes with paper interleaves, sheet film has a notch code in the top right corner to identify the film type and the emulsion side of the film for loading in complete darkness. The large negatives are often contact-printed rather than enlarged.

 see Contact Print 74, Format 127, Roll Film 209

Untitled Film Still (#21), 1978.

Sherman (born 1954) is an American photographer best-known for her conceptual portraits. This image is from her *Complete Untitled Film Stills* (1977–1980) where she explores issues of the individual, and female stereotyping, appearing herself as a B-movie actor acting out a range of roles. The images all look like publicity shots from movies you remember well but have never seen. Sherman does not consider her work as a feminist critique nor as self-portraiture. Her more recent work has used colour and historical settings.

Shutters are used to control light entering the camera – our darkened room – just as shutters fitted over a window control light entering a room. The shutter mechanism is used to expose the film or sensor for an exactly measured time interval. Thin curtains of metal foil, cloth or plastic or metal blades are used initially as a light seal and then opened and closed over an exact time period by springs, magnets or motors. The shutter controls the duration of light in the reciprocal intensity/duration relationship and thus influences the appearance of movement – or complete lack of it – in the final image.

☞ see Camera 48, Focal-Plane Shutter 125, Leaf Shutter 153, Reciprocity 200, Shutter Speed 224

Shutter priority is a semi-automatic exposure mode that lets the photographer choose a shutter speed while the camera automatically chooses a matching aperture to produce a good exposure.

Shutter priority is ideal for times when a fast shutter speed is needed to prevent camera shake with long lenses, to capture peak action on the sports field or when capturing a bird in flight, as pictured here.

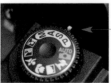

The mode is marked S (Shutter) or TV (Time value) on the camera mode dial or menu.

☞ see Aperture Priority 28, Auto Exposure 34

The precisely controlled time the shutter stays open during exposure – usually measured in fractions of a second. Between-the-lens leaf shutters commonly achieve a maximum speed (time) of 1/500 sec. Focal-plane shutters, which feature a travelling slit, can achieve times up to 1/8,000 but do not expose the whole frame at precisely the same moment, which has implications for flash synchronisation. Synchronisation speed is the maximum shutter speed that can be used with flash.

1

1/2

1/4

1/8

1/15

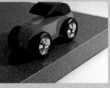
1/30

1/60

1/125

1/250

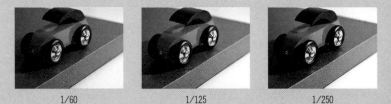

☞ see Focal-Plane Shutter 125, Leaf Shutter 153, Shutter 222

Side lighting is light that shines directly from the side of the subject across the camera axis, lighting the side of the subject facing the light source and casting the other into shadow. In portraiture, if there is no light reflected back into the shadowed side of the face, this creates the very dramatic look of split lighting, so-called because it splits the face down the centreline of the nose into a lit side and a dark side. The strength of the effect can be moderated with a reflector. Side lighting will enhance textures in the surfaces of the subject facing the camera.

☞ see Backlighting 37, Front Lighting 131, Reflector 203, Rim Lighting 207, Three-quarter Lighting 246

A silhouette is the dark shape of the subject seen against a lighter background. This usually means a backlit subject seen in its own shadow or an unlit subject against a bright background. Silhouettes show no colour or textural detail.

Silhouettes are used for graphic strength, as shown in this image of the nose cone of a XB-70 Valkyrie supersonic bomber. Exposing for the sky produces a strong black silhouette from the hangar door. Image captured with a Nikon D70 18–70mm f/3.5–4.5G AF-S DX IF-ED Zoom-Nikkor at 31mm, 1/200 sec at f/11, ISO 200.

A box of silver gelatin fibre paper, a stack of fibre prints and a matted
and framed silver gelatin exhibition print.

The description given by galleries to conventional black-and-white photographic prints on fibre paper, named after the image-forming gelatin layer that contains the photosensitive silver salts (the emulsion layer). Gelatin is an animal by-product of the hog and cattle industries and is made from animal bone after all mineral elements have been removed. Its ability to swell allows chemicals to access the silver salts in the emulsion and to wash the film free of chemicals once the silver image has been formed. Gelatin is used for both photographic paper and film.

The silver halides are the family of salts made when silver (Ag) reacts with a halogen. Of these, only chlorine (Cl), bromine (Br) and iodine (I) are of interest to the photographer. Given the pseudo-chemical notation AgX, they are the light-sensitive chemicals used in photographic paper and film. They create a crystal lattice, which contains free silver ions (Ag+). When light energy hits the crystal, it knocks a negative charge off a halide ion that immediately finds the silver ion and makes it a speck of metallic silver. These specks can be chemically amplified by a suitable developer to create black silver where the light struck the film.

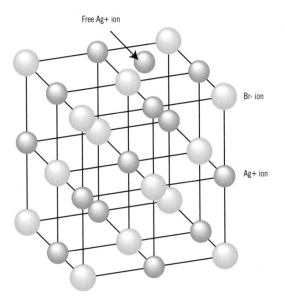

Free Ag+ ion

Br- ion

Ag+ ion

☞ see Developer 87

This medium-format (6x7cm) camera is not fitted with a prism, instead it features a viewing hood with magnifier. An instant return mirror is a convenience. Despite this, the only thing you do not see through an SLR is the precise moment the picture is taken. You are looking at the back of the mirror!

The SLR camera has just a single lens and a mirror. Shown in cross-section (above right), the mirror angled at 45° lets the photographer look down into a viewing chamber to see exactly the same view as the lens. During exposure the mirror swings up out of the light path, the shutter opens and the image is created on the film or sensor inside the camera. SLR cameras originally featured ground-glass screens for viewing. Although popular since the early 20th century, only in 1948 did Zeiss add a five-sided prism to erect and invert the mirrored image to present it at eye level for correct viewing. All modern SLRs and digital SLRs (D-SLRs) use this pentaprism or similar arrangement of mirrored surfaces.

☞ see Twin Lens Reflex (TLR) 256

A CONICAL LIGHT SHAPER THAT RESTRICTS THE BEAM OF
LIGHT FROM A LAMP OR FLASH HEAD. THIS CREATES AN
UNFOCUSED POOL OF STRONG LIGHT THAT IS OFTEN USED TO
HIGHLIGHT A SPECIFIC FEATURE IN A STILL LIFE OR TO ACT AS
AN EFFECTS LIGHT IN PORTRAITURE. A HIGH-POSITIONED,
DOWNWARD-FACING SNOOT IS OFTEN USED AS A HAIR LIGHT
IN PORTRAITURE: IT CREATES A CONTROLLED HIGHLIGHT AREA
IN THE HAIR TO LIFT IT VISUALLY FROM THE BACKGROUND.

A source of diffuse photographic light – a floodlight, in other words. A soft box is a box or frame covered with translucent (light-diffusing) material used over a flash head to create a soft light. Soft boxes are available in various sizes and come in strip, rectangular and larger 6- or 8-sided forms. All can be referred to as area lights. Smaller soft boxes are sometimes called 'fish-fryers', the biggest may be referred to as 'swimming pools'. Window-sized soft boxes may take the name 'northlight' after the effect they produce which is similar to that from a north-facing window. The diffuse light from a soft box can be further softened with the addition of an 'egg-crate', a black sectional mask that breaks up the big single area into an array of smaller, soft light sources.

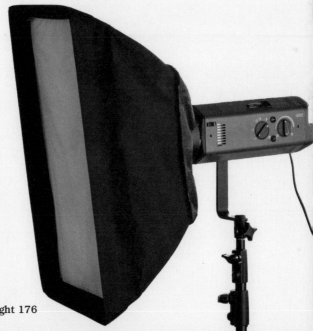

☞ see Northlight 176

Small moulded lenses on surface of soft focus filter can be seen in its shadow.

True soft focus is achieved with a soft-focus lens or filter; this is not the same as a blurred, out-of-focus/de-focused or diffused image. The Zeiss Softar filter pictured is a flat resin filter covered with tiny moulded lenses of different sizes and power that create a halo of differently focused images around the central image given by the camera lens. The overall effect is an image that is in focus but has a halo of out-of-focus images around it. Easy to overuse, the effect is common in glamour photography and in portraits of women and children, to achieve a dream-like effect.

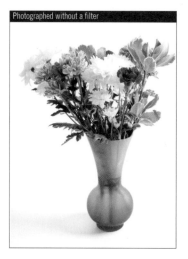

Photographed without a filter

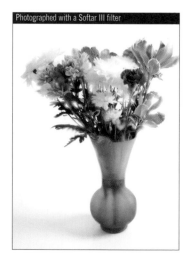

Photographed with a Softar III filter

SPHERICAL ABERRATION IS A LENS FAULT THAT OCCURS WHEN RAYS THAT ARE CLOSE TO THE CENTRE OF THE LENS (ITS OPTICAL AXIS) FOCUS FURTHER AWAY THAN THOSE THAT STRIKE THE OUTER ZONES OF THE LENS, WHICH ARE BENT MORE. THIS RESULTS IN A SOFT (INDISTINCT AND FUZZY) IMAGE THAT LACKS CRISP CONTRAST. THESE FAULTS COME ABOUT BECAUSE IT IS EASY TO GRIND GLASS LENSES AS PARTS OF A SPHERE, WHICH IS NOT ALWAYS OPTICALLY IDEAL. ASPHERIC ELEMENTS, WHICH ARE MOULDED AND POLISHED LENSES THAT DO NOT HAVE A SPHERICAL CURVED SURFACE, ARE MORE EXPENSIVE TO MAKE BUT ARE NOW INCORPORATED IN MANY MODERN LENSES TO CORRECT SPHERICAL, AND OTHER, ABERRATIONS.

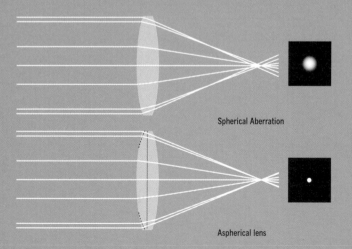

Spherical Aberration

Aspherical lens

Split toning is when the highlights of an image are toned differently from the shadows. The commonest darkroom split toning is sepia/selenium toning. Digital split toning offers a far wider spectrum of colours and total control of the tone at which the split occurs but it is very easy to produce garish or visually unattractive images and many workers stick with classic darkroom 'looks'.

Sepia/selenium toning mixes brown-toned highlights from sepia blended through brown-black mid-tones to purple-black selenium-toned shadows to produce the very rich overall effect seen in this darkroom print of a tree bole and roots in Highland Park, Rochester, NY, USA.
Image captured with a Leica R8, 35–70mm Vario-Elmar zoom. Kodak TMAX 100 film, ISO 100.
Developed in Kodak D-76, printed on Ilford Multigrade IV paper, sepia and selenium toned.

☞ see Highlight 138, Shadow 218, Toning 253

Spot readings can be taken from a mid-tone in the image or an average exposure calculated
from readings of shadows and highlights. Spot meters are favoured by zone system workers
for their precision in measuring small areas of tone.

THE SPOT METER IS A REFLECTED LIGHT METER
THAT TAKES A MEASUREMENT FROM A SMALL PART
OF THE SUBJECT ONLY. INDIVIDUAL TONES CAN BE
ACCURATELY MEASURED IN THIS WAY AND AN AVERAGE
EXPOSURE CALCULATED. SPOT METERS INCORPORATE
A SIMPLE TELESCOPE VIEWFINDER – SOMETIMES WITH
A ZOOM RANGE – WITH A SMALL CIRCLE THAT MARKS
THE AREA FROM WHICH THE METER TAKES ITS
READING. HAND-HELD SPOT METERS HAVE AN
ACCEPTANCE ANGLE RANGING FROM 1° TO 5°; A
1° CIRCLE IS THE SIZE OF A DINNER PLATE ABOUT
12 METRES (40FT) DISTANT. A CAMERA SPOT-METER
FUNCTION DOES NOT OFFER READINGS FROM SUCH
A TINY SPOT AND IS REALLY SMALL AREA METERING.

see Light Meter 156, Zone System 270

A standard or normal lens is one with a focal length that comes close to equalling the diagonal of the format for which it is designed. This gives an angle of view roughly equivalent to normal human vision. A standard lens will give a 'natural' perspective in a 10x8in print held at arm's length. For 35mm and full-frame digital cameras, the format diagonal is a little over 43mm and standard lenses fall in the 45–60mm range. A standard lens for a 6cm-square medium-format camera is an 80mm lens; for a 5x4in large-format camera it is a 150mm lens.

Broadstairs Beach, Kent, UK, 1984.
Image taken with Nikon F2A 55mm f/2.8 Micro-Nikkor. Fujichrome 50 RF film, ISO 50.

☞ see Angle of View 26, Perspective 184

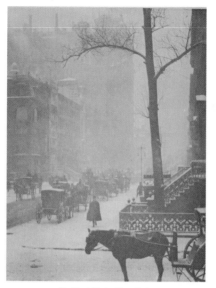

The Street: Design For a Poster.

Alfred Stieglitz (1864–1946) was one of the most important and influential
individuals in the development of photography as an art form in the twentieth
century. He fervently supported the pictorialist style, going so far as to declare
a Photo-Secession or breakaway group to promote this through his magazine
Camera Work. Later, he introduced American photographers and artists to
African and European avant-garde art through his New York gallery 291; he
was possibly the first person to put gallery prices on photographs, equivalent
to paintings or drawings. His 1922 series of cloud photographs, *Equivalents*, are
seen as the first set of deliberately abstract images from a major photographer.

He abandoned the pictorial style for the cleaner, more honest approach of
modern 'straight' photography, supporting important photographers and artists
such as Paul Strand, Georgia O'Keefe (his second wife) and Edward Weston.

☞ **see Pictorialism 190, Strand, Paul 240**

Stitching is the process of joining individual
overlapping images, using software, to form a
composite panorama.

Pictured are five individual images stitched into a single panorama showing the end of
industry on the west coast of the English Lake District.

☞ see Panorama 181

One stop is simply a halving or doubling of light.
It is a relative, not an absolute, term and can be used
in relation to shutter speed, film speed, sensitivity or
aperture. Photographers use the expression 'stop'
when referring to changes in exposure.

Stop is also shorthand for 'stop bath', a mild acid used
to arrest development in film and paper processing.

The term is derived from the Waterhouse stop – a set of which is shown here – named after John
Waterhouse of Halifax, England, who invented these circular holes in thin strips of metal in 1858. Called
'stops' because they stop some of the light passing through the lens, each lets through twice as much
light as the smaller stop in the sequence and half as much light as its bigger neighbour.

Paul Strand (1890–1976) was born in America to European parents. He was a student photographer with the documentarian Lewis Hine when he saw the work of Alfred Stieglitz and Edward Steichen on a class trip to the 291 gallery run by Stieglitz in New York. Strand was encouraged to pursue photography. His early work was in the soft-focus style of pictorialism and he developed a strong, formal modernist, abstract approach. Stieglitz championed Strand's work and they can together be considered founders of American modernist photography. Strand also worked as a filmmaker, leaving America at the time of the McCarthy 'witch hunt' because of his political beliefs.

White Fence 1916.

☞ see Stieglitz, Alfred 237

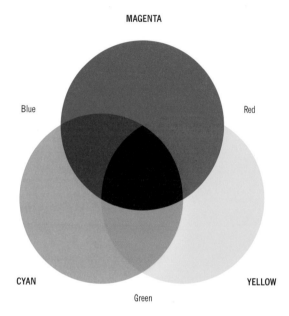

MAGENTA

Blue Red

CYAN YELLOW

Green

White light is an equal mix of red, green and blue light: the additive primary colours. Take any one of these primaries away from white and you are left with cyan (white minus red), magenta (white minus green) and yellow (white minus blue). Mix the subtractive primaries together as pigments and you theoretically get black. While RGB is the additive world of light and the digital sensor, CMY is the world of reflected light and printing, where these colours are used as dyes or pigments in inks on paper that act as filters on the reflected white light to create the range of visible colours.

☞ see Additive Colour 21

Fitted with the ease of a filter, supplementary lenses are easy to carry and do not cut out light.

The typical close focusing and shallow depth of field is shown in this image of a rose, which was taken with a 135mm lens with close-up attachment.

Supplementary lenses are simple magnifying lenses, sometimes called close-up lenses, fitted to the front of an existing camera lens for close-up photography. They do not reduce the lens aperture (unlike bellows or extension tubes). The best are cemented achromatic doublets – two pieces of matching glass – that are free of lens distortions such as chromatic aberration. Often sold in sets, their strength is measured in dioptres. A set will usually contain +1, +2 and +4 dioptre lenses that can be stacked for additional magnification. A dioptre is 1/focal length (in metres) so a 2-dioptre lens on its own will focus at $^1/_2$ metre.

☞ see Chromatic Aberration 54, Macro Photography 157

Some manufacturers' dedicated tele-convertors minimise potential problems of chromatic or geometric lens aberrations and retain data communication between lens and camera for auto and flash exposure.

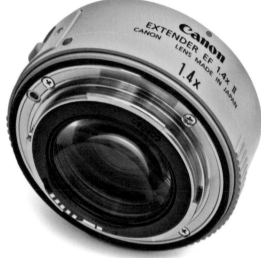

TELE-CONVERTERS ARE SUPPLEMENTARY LENS SYSTEMS FITTED BETWEEN THE LENS AND CAMERA BODY TO EXTEND THE EFFECT OF TELEPHOTO LENSES. THEY COME IN A RANGE OF POWERS: x1.4; x1.7 AND x2 ARE COMMONLY OFFERED. A x2 TELE-CONVERTER WILL DOUBLE THE FOCAL LENGTH OF A LENS, MAKING A 600MM LENS A 1,200MM OPTIC, WHEREAS A x1.4 WOULD GIVE IT AN 840MM FOCAL LENGTH. SADLY, A x2 CONVERTER WILL ALSO HALVE THE APERTURE, MAKING A 600MM F/4 LENS A 1,200MM F/8.

☛ see Telephoto Lens 244

A type of long-focus lens with an optical design that means it is physically shorter than its optical focal length. The terms long focus and telephoto are used interchangeably nowadays but there is this technical difference. Telephoto lenses have narrow angles of view and long focal lengths. For 35mm and full-frame digital cameras, a 135mm lens is considered a short telephoto. True telephoto lenses start at a focal length of 180–200mm. Many telephoto lenses are now designed as zooms, bar the extreme focal length lenses between 800 and 1200mm, which are sometimes folded mirror (reflex) designs for compactness.

The classic background blur and pronounced depth-of-field changes can be seen here. This image was taken at the 300mm end of a 70–300mm f/4-5.6D AF ED Zoom-Nikkor, fitted to a digital camera body with a crop factor of 1.5, making this act like a 450mm telephoto.

☞ see Angle of View 26

LIGHTING THAT FALLS ACROSS ANY TEXTURED SURFACE
WILL HIGHLIGHT EACH PROTRUDING PART OF THE
MATERIAL AND CAST A DEEP SHADOW BEHIND. THIS
MICRO CONTRAST IS WHAT WE SEE AS TEXTURE. HARD,
DIRECTIONAL LIGHT WILL SHOW MORE OF THE EFFECT
THAN A SOFT, DIFFUSE LIGHT SOURCE. THE ANGLE AT
WHICH THE LIGHT 'STRIKES' THE SURFACE IS IMPORTANT.
THERE WILL BE LITTLE TEXTURE WHEN LIGHT FALLS
DIRECTLY ON TO THE SUBJECT – FLAT LIGHTING – BUT
AS SOON AS THE LIGHT IS ANGLED TO RAKE OVER THE
SURFACE IT WILL REVEAL TEXTURE.

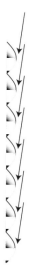

High-angled sun reveals the texture of weather-beaten wood. Image captured with Nikon D100
60mm f/2.8D AF Micro, 1/60 sec at f/19, ISO 200.

In portraiture, three-quarter lighting comes from an angle of 45 degrees relative to the centreline of the head. It can come from camera left or right. This lights one side of the face well, yet puts enough light on to the shadowed side of the face to model it. It is of course a compromise between the deep shadows of side lighting and the flat light from front lighting. The pleasing fall of light and shadow will model the face and reveal its three-dimensional qualities, its form and volume.

☞ see Backlighting 37, Front Lighting 131, Rim Lighting 207 and Side Lighting 225

Thumbnail images are very small previews of image content used by computer operating systems and cataloguing (digital asset management) software. A screen of thumbnails is quicker to scan than opening large files one by one. Minilabs now routinely print thumbnail index prints of processed films and digital camera cards.

TIFF stands for Tagged Image File Format, although this is no longer referenced in the current standards. It is a raster (line-by-line) image format that can support some forms of lossless compression to reduce file size. TIFF was originally produced as a format for image scanners by the desktop publishing pioneers Aldus; it is now under the control of Adobe Systems Inc, of Photoshop and Postscript fame, which merged with Aldus in 1994. The tags are header tags that contain details of the image size, its definition and image-data arrangement (i.e. whether the data is read in rows or columns).

☞ see JPEG 146

Once you press the shutter on a camera or shutter with a T-setting, it stays open until you press the shutter release again or, in some cases, until the batteries run out. On lenses for large-format cameras, the T-setting is sometimes used to open the lens to project an image on the viewing screen in order to focus and compose the image. Any movement of the subject is integrated throughout the period of the exposure and appears as motion blur: star trail pictures are a good example. Because of the dim image projected, pinhole cameras rarely take instantaneous pictures but show the passage of time during the exposure.

Toning is historically based on chemical alteration of the silver-halide image, while tinting means dyeing or painting on the image and can involve a much wider palette of colours. Tinting can also be used to mean colourise. This means taking a greyscale image and changing all the grey tones for a range of tones of the same colour to produce a monochrome (single-colour image). Hand tinting refers to colouring a monochrome print with oils, crayons or dyes.

☞ see Monochrome 166, Toning 253

In photography, 'tone' is taken to refer to a shade of grey or a range of grey tones in an image. A wide tonal range would refer to an image containing every shade of grey from full black to paper white. A restricted tonal range would refer to an image lacking some part of the tonal spectrum. Artists use the term to mean the lightness/darkness of a colour.

An image-processing technique used to make a high dynamic range (HDR) image more closely matched to human perception when shown through a necessarily more limited dynamic range medium. Tone mapping controls the massive contrast range of an HDR image and reveals shadow and highlight detail in a natural way. Some tone mapping software will work additionally on 16-bit images as well as 32-bit HDR images.

Original image

Tone-mapped version

☞ see Dynamic Range 100, HDR 137, Highlight 138, Shadow 218

This image of drying fishing nets was taken in Maryport, Cumbria, UK. It is a conventional black-and-white darkroom print scanned and digitally toned with cyan/blues in the shadows and golden-yellow in the highlights, which would be difficult to achieve chemically.

Image captured with a Bronica RF-645 65mm f/4 Ilford HP5 Plus and developed in Prescysol EF. Scanned from a 10x8 inch print on Ilford Multigrade IV paper and tritoned in Photoshop.

Toning – chemically changing the image – was originally done to stabilise photographs and prevent them from fading. Darkroom toning involves changes to the chemistry of the silver halide image. Photographers tone their images either for archival purposes (selenium toning), for aesthetic reasons (sepia or vanadium toning), or both (gold toning). Digital toning alters the colours of a monochrome image to imitate the look of classic darkroom toning or simply to colourise an image.

☞ see Selenium Tone 215, Sepia Tone 217, Split Tone 234, Tint 250

THE FAMILIAR THREE-LEGGED CAMERA SUPPORT USED
TO ELIMINATE BLURRING FROM CAMERA SHAKE DURING
LONG EXPOSURES OR WITH TELEPHOTO LENSES. THE
CAMERA IS USUALLY REMOTELY TRIGGERED WITH A
BULB, CABLE-RELEASE, ELECTRICAL OR INFRARED
REMOTE TO REMOVE ANY OTHER SOURCE OF VIBRATION.
CAMERAS CAN BE SCREWED DIRECTLY TO THE TRIPOD
HEAD OR FITTED WITH A QUICK-RELEASE PLATE.

LEGS MAY HAVE TELESCOPIC EXTENSIONS AND ON
SOME MODELS THEY CAN BE INDEPENDENTLY ADJUSTED
TO ANY ANGLE. TRIPOD HEADS ARE USUALLY
INTERCHANGEABLE AND ARE COMMONLY FITTED WITH
THE FOLLOWING: THREE-WAY HEADS WITH THREE
DEGREES OF FREEDOM; PAN-AND-TILT HEADS WITH TWO
DEGREES (MORE OFTEN USED FOR VIDEO CAMERAS) AND
BALL HEADS THAT ARE ADJUSTABLE IN ANY DIRECTION.

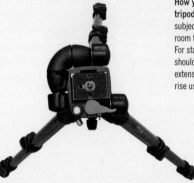

How you should see your
tripod: one leg forward facing the
subject to support the lens, with
room for you to work at the back.
For stability, thick leg extensions
should be used before thin
extensions and the centre column
rise used only as a last resort.

see Monopod 167

Tungsten light is that from incandescent (glowing) light bulbs, which have elements made of tungsten metal. It is a yellow light with a warm quality and a colour temperature of around 3200–3400K. This is the light from classic household bulbs, not modern energy-saving bulbs. Taking pictures in tungsten light on daylight film without an appropriate colour conversion filter (80A) results in yellow-orange prints. Tungsten is one of the white balance settings on a digital camera. It ensures neutral images free from any colour cast under these lights.

see Colour Conversion Filters 62, Colour Temperature 70, Fluorescent Lighting 121, White Balance 266

The Twin Lens Reflex (TLR) camera attempted to overcome limitations in the early SLR camera. With one lens and mirror (long before the introduction of the instant return mirror), the SLR camera blacked out as the picture was taken until the mirror was reset. Shown in cross-section, the TLR camera has two lenses and one mirror. The lower taking lens has a shutter and images through a darkened chamber on to the loaded film. Above, a second lens is backed by a fixed mirror, angled at 45°, letting the photographer look down on to a ground-glass viewfinder to focus and compose. The image is upright but left-to-right reversed. The advantage of the TLR is that the viewing lens does not black out when the picture is taken.

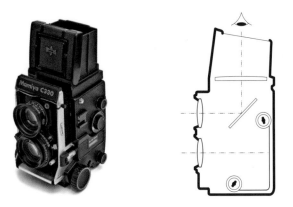

A classic Mamiya TLR roll-film camera, which offered interchangeable lens pairs unlike the more famous fixed lens Rollei TLRs. These cameras were popular with fashion and portrait photographers as they gave continuous sight of the subject. However, with separate viewing and taking lenses they suffer from parallax problems with close subjects.

☞ see Parallax 183, Single Lens Reflex (SLR) 229

A glass or plastic filter that fits over a lens to filter out ultraviolet light. Although they have some small effect on haze at altitude, UV filters are more commonly fitted as lens protectors because they have no effect on light in the visible spectrum.

☞ see Electromagnetic Spectrum 104

Diffuser umbrellas are made from translucent white
material and can be used to break up the direct light
from a flash head or as a weak reflector.

Reflecting umbrellas are black umbrellas lined with
white or silver reflective material. They are used with
the flash head facing away from the subject, with the
illuminating light reflected from the internal surface
of the umbrella. Highly reflective
umbrellas give a strong,
contrasty light, while
diffuser umbrellas
give a softer light,
more like that
from a soft
box.

In photography,
umbrellas are used
as reflectors and
diffusers with
flash heads.
They collapse
like a
conventional
umbrella for
storage.

☞ see Reflector 203, Soft Box 231

Unsharp mask dialog

Original image

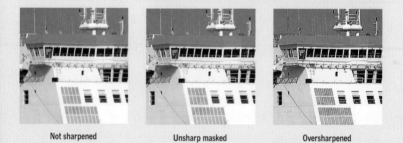

Not sharpened

Unsharp masked

Oversharpened

An unsharp mask is used in large-format photography to increase edge contrast and thereby apparent sharpness of an image. A print is made by sandwiching the original negative with a weak positive contact print – made blurred to avoid registration problems and enhance the edge effect. The blur or 'unsharpness' is achieved by contact printing the mask through the film thickness, not emulsion to emulsion, or by using a clear acetate spacer.

Unsharp masking is more likely to be encountered in a Photoshop sharpening dialog box. It is a similar technique for enhancing edge-contrast but used for digital images. The degree of contrast enhancement (Amount) can be adjusted along with the edge width (Radius) and what brightness difference is to be considered an edge (Threshold).

☞ see Acutance 19, Sharpening 219

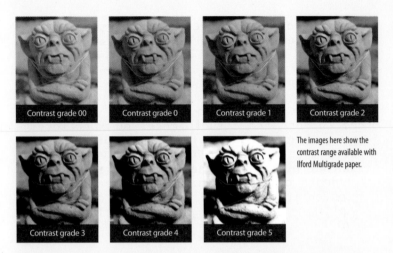

Contrast grade 00

Contrast grade 0

Contrast grade 1

Contrast grade 2

Contrast grade 3

Contrast grade 4

Contrast grade 5

The images here show the contrast range available with Ilford Multigrade paper.

Variable contrast paper is black-and-white photographic darkroom paper that can be exposed to give a range of different contrasts matching a wide variety of negative contrasts. Contrast can be adjusted by exposing the paper through a range of yellow to magenta filters (complementary colours). The filters can be used above or below the enlarger lens and give a range in half grades from soft (Grade 00) to hard (Grade 5). Variable-contrast enlargers feature a single control for contrast, which gives stepless contrast grades without requiring retesting or calculation for exposure when the paper grade is changed.

see Complementary Colours 71, Contrast 76, Enlargement 105

View cameras are simple, large-format cameras with a lens on a board attached to a film holder by a set of bellows. The 'view' comes from the fact the film holder (dark slide) can be substituted by a ground-glass screen that shows the image reversed and upside down. These are the only cameras where you frame and compose the actual image you will later capture. Having complete freedom of movement with the film and lens planes gives total control over the plane of focus, shape and depth of field. This is limited in a conventional camera, where film and lens planes are fixed and parallel. The use of large-format sheet film ensures high image quality.

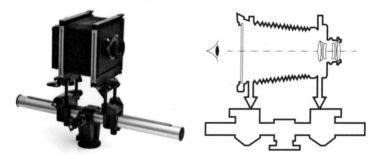

View cameras that are built around a strong tube or rail are Monorail cameras; some are built on a flatbed or baseboard. Cameras clearly designed for indoor use are often called Studio cameras. Others sacrifice full adjustment of the back plane as this is held inside a clamshell case, allowing the bed to be closed up and the camera transported. These are called Field cameras or Technical cameras.

☞ see Double Dark Slide 94, Ground-glass Screen 136, Movement 168, Sheet Film 220

Optical viewfinders are independent lens systems allowing the photographer to frame and compose an image. They do not show what the lens 'sees', as with an SLR camera. The so-called 'Albada' finder features a half-silvered frame that matches the focal length and format in which the image is framed in a direct-vision viewfinder of a wider angle of view. Subjects outside the image frame are usefully shown and the viewfinder image can always be seen clearly, even in dim light. A viewfinder may not show exactly what the lens is taking when used close-up. Electronic viewfinders (EVF) overcome the limitations of rear screens on digital cameras in bright ambient light. They are simple LCD screens set in the dark interior of the camera with an optical viewing system.

An 8 MegaPixel SP350 digital compact zoom camera (2005) features a tiny zooming optical viewfinder, despite having a large rear LCD screen. Shown behind is a 35mm half-frame classic (1962), the Pen D, which relied solely on the optical viewfinder with parallax lines for framing.

☞ see Parallax 183, Single Lens Reflex (SLR) 229

High vertical viewpoint

Angled viewpoint

Low horizontal viewpoint

Viewpoint is the single point in three-dimensional space where the camera is placed that determines the final perspective in the finished two-dimensional image. Choosing alternative viewpoints can show simple objects in a new or revealing light; this is one of the chief ways in which a photographer will explore their subject. It is easier to think of viewpoint as point of view, which accurately captures both physical and narrative aspects.

☞ see Perspective 184

Vignetting is the unwanted fall-off of light at the frame's edge –
a limitation of some wide-angle lens designs. Alternatively, it can refer
to a presentation and printing technique that blends the image edges,
usually from a central oval shape, towards either white or black. With
modern software, the mid-point of this blend can be adjusted. Taking
a vignette to full paper white or solid black is nowadays considered
to produce an old-fashioned look.

Note the centre of each image is identical, although their moods are very different.

The warm colours in this image of a restuarant in Rome, Italy (right), were captured using a Leica M6TTL with a 35mm Summilux f/1.4 lens on Kodak Elite Chrome EB100 (5045) film, ISO 100.

Warm colours are those in the red-to-yellow segment of the colour wheel. This is a psychological association and is not based on the colour temperature scale. Warm-tone photographic paper produces a distinct brown black. Warm-up filters, such as the Wratten Series 81 light-balancing filters, actually lower the numeric colour temperature but have the effect of making the image appear less cold (i.e. less blue), hence their name.

☞ see Colour and the Colour Wheel 60, Colour Conversion Filters 62, Cool Colours 77

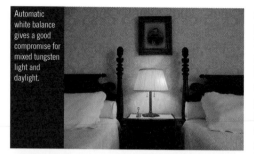

Automatic white balance gives a good compromise for mixed tungsten light and daylight.

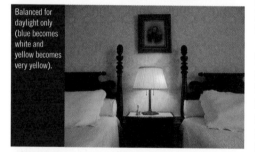

Balanced for daylight only (blue becomes white and yellow becomes very yellow).

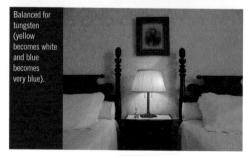

Balanced for tungsten (yellow becomes white and blue becomes very blue).

As any white object reflects most of the illuminating light, it will take on the colour of the illuminating light source and only appear neutral white in photographic daylight or daylight-balanced flash. It will show anything from an orange-yellow to a strong blue colour cast under light of differing colour temperatures.

White balance has a major effect on our photographic images. It can be corrected by introducing the complementary colour, which restores neutrality. Film uses filters; digital cameras feature AWB (Automatic White Balance) and manual control on the camera. White balance can also be adjusted using computer software.

☞ see Colour Cast 61, Colour Conversion Filters 62, Colour Temperature 70, Complementary Colours 71, Kelvin 147

A wide-angle lens has a wide angle of view and a shorter than standard focal length. The shorter the focal length, the wider the angle of view. A popular first choice is the 35mm- or 28mm-wide angle as the viewpoint effects can take some adjustment of photographic technique. Super-wide- and ultra-wide-angle lenses need care in their application to avoid repetitious compositions, although their use is essential to some architectural and industrial photography where views of 90° and more are required in cramped spaces.

An open-air museum street scene showing the strong convergence of lines and dramatically receding background; this was taken with the equivalent of an 18mm super-wide-angle lens with a 90° angle of view.

☞ see Angle of View 26

Workflow follows the processes applied to the creation and use of a digital image. This includes all stages from pre-shoot planning to output in different sizes and forms for different media and the cataloguing necessary to keep track of this file among all the others. In between, the image has to be captured, transferred from camera to computer and processed to produce the best-quality image. Picture content may even be edited or altered. Some computer software such as Apple's Aperture and Adobe Systems Photoshop Lightroom now incorporate large parts of the image workflow in one convenient application.

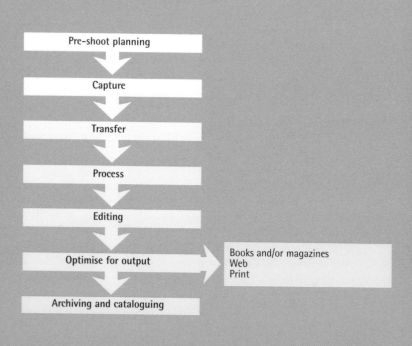

Filter	Wratten number	
Medium yellow	8	
Yellow-green	11	
Deep yellow	12	
Yellow-orange	16	
Orange	22	
Red	25	
Deep red	29	

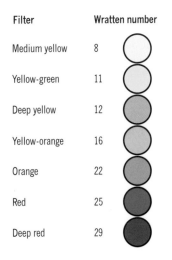

The Wratten numbering scheme for filters is named after Frederick Wratten, who sold his coloured filter company to Eastman Kodak at the beginning of the 20th century. Wratten numbers can seem confusing but are still used in America and the UK today. The major Wratten series are the colour conversion filters: the deep-blue 80 series and deep-orange 85 series used for making major shifts in colour temperature; and the Wratten light-balancing series filters. These raise or lower colour temperature in much smaller steps than the colour conversion filters: 81 series filters (yellow-amber) lower the colour temperature and 82 series filters (light blue) raise the colour temperature over a range of several hundred degrees. Colour takes a number and strength a letter, with A the weakest and F the strongest. An 81D warm-up filter produces a greater effect than an 81A filter. The diagram shows the Wratten numbers for filters commonly used for black-and-white photography.

☞ see Colour Conversion Filters 62, Colour Temperature 70, Filter 116

Ansel Adams's Zone System was his revision of work by John L Davenport originally published in 1940 in US *Camera* magazine. In 1941, Adams and his co-worker, Fred Archer, created the Zone System as a series of practical tests and processes for large-format camera users so they could control exposure and produce the best possible quality prints that matched their visualisation of the subject.

Zone System after Ansel Adams

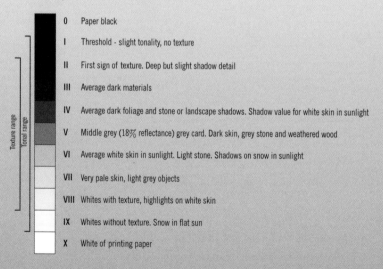

Zone	Description
0	Paper black
I	Threshold - slight tonality, no texture
II	First sign of texture. Deep but slight shadow detail
III	Average dark materials
IV	Average dark foliage and stone or landscape shadows. Shadow value for white skin in sunlight
V	Middle grey (18% reflectance) grey card. Dark skin, grey stone and weathered wood
VI	Average white skin in sunlight. Light stone. Shadows on snow in sunlight
VII	Very pale skin, light grey objects
VIII	Whites with texture, highlights on white skin
IX	Whites without texture. Snow in flat sun
X	White of printing paper

Texture range

Tonal range

☞ see Adams, Ansel 20, Exposure 108, Highlight 138, Light Meter 156, Shadow 218, Spot Meter 235

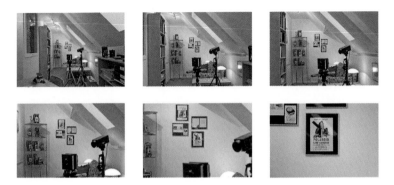

Zoom ranges of common kit lenses 18-55mm and 70-300mm.

Top row (left to right) zoom range at 18mm, 35mm and 55mm. Bottom row (left to right) zoom range at 70mm, 135mm and 300mm.

Rather than having a single fixed focal length, as on a prime lens, a zoom lens has a continuously variable focal length. The focal length range will be specified: 18–200mm or 12–24mm. Sometimes the zoom will be described as being a 5x zoom. To reach this figure you divide the longest focal length by the shortest. For example, an 80–200mm zoom would be a 200/80 = 2.5x zoom.

Digital zooming is that done purely in software, as opposed to optical zooming, which is done physically by moving lens elements. The centre of the maximally zoomed optical image is made to fill the full digital frame. Apparent focal length increases but no real detail is added. The downside of digital zoom is that you could probably do it better on your computer.

☞ see Aperture 27, Prime Lens 196, Stop 239

The Details

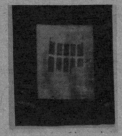

1700–1824
Technology
Johann Heinrich Schulze
discovers sensitivity of
silver nitrate to light.
Thomas Wedgwood makes
sun prints of leaves and
paintings on white leather
impregnated with silver
nitrate and salt; findings
reported by Sir Humphrey
Davy.
Joseph Nicéphore Niépce
makes first printed-out
paper negative (partially
fixed) of camera obscura
image.
Sir John Herschel discovers
that sodium thiosulphate
will 'fix' silver images.

Culture
Camera obscura and lenses
used as drawing aids by
artists. Silhouettes, which
are portrait outlines in cut
black paper, are popular.

1825–1834
Technology
First permanent image
on photosensitised pewter
produced by Niépce.
William Henry Fox Talbot
creates permanent negative
images on paper and
positive contact prints.

Culture
First lens-based
photographic image taken
from nature.

1835–1839
Technology
Louis Daguerre produces
fine-quality images on
silver-plated copper
sensitised with iodine
and developed with
mercury fumes.
Herschel establishes the
words photograph and
photography.
Fox Talbot announces
negative/positive process
to Royal Society in London.

Culture
Fox Talbot develops
'photogenic drawing' paper
negative of window at
Lacock Abbey.
Daguerre makes first image
to include a person in a
street scene from his
apartment window.

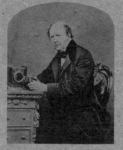

1840–1844
Technology
Fox Talbot patents his
negative/positive process
as the Calotype.

Culture
Fox Talbot publishes
The Pencil of Nature
in 1844, the first book
to be illustrated with
photographs.

1845–1849
Technology
Albumen process
introduced.
Stereoscope invented.

Culture
Artists become attracted
to new medium. David
Octavius Hill and Robert
Adamson set up a
photographic studio in
Edinburgh, Scotland.

1850–1854
Technology
Frederick Scott Archer
shows, but does not patent,
wet-plate collodion process.
Fox Talbot takes the first
photograph of a moving
object 'frozen' by
electric spark.

Culture
First international open
photographic competition
held during London's Great
Exhibition. Photographic
reproduction on industrial
scale in France, for artists
and amateurs alike:
Imprimerie Photographique.

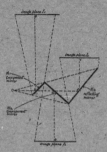

1855–1859
Technology
Aplanat lens introduced
correcting certain lens
aberrations.
Magnesium flash first used.

Culture
Oscar Rejlander produces
composite images on
allegorical themes.

1860–1864
Technology
James Clerk Maxwell shows
additive colour images from
three black-and-white
photographs, taken through
red, green, and blue filters.
Focal-plane shutters
first used.

Culture
Matthew Brady's US Civil
War images cause sensation
when seen in galleries,
periodicals and on his
lecture tours.

1865–1869
Technology
Louis Ducos du Hauron
outlines various methods
of subtractive colour
photography with
beam-splitter camera.

Culture
Julia Margaret Cameron
shows close-cropped
portraits of the famous
(still influential) and
soft-focus aesthetic images
based on legendary, literary
or allegorical themes.

1870–1874
Technology
Dr Richard Leach Maddox proposes 'dry plates': silver gelatin on glass.

Culture
First photographs of the American West. French police use photographs to document crime scenes.

1875–1879
Technology
Eadweard Muybridge creates sequenced image of horse galloping showing all four feet simultaneously off the ground.

Culture
Photographic images showing the human and animal form in rest and locomotion are used as reference material by artists.

1880–1884
Technology
George Eastman sets up dry-plate manufacture in Rochester, NY.

Culture
Photographic emulsions now fast enough to liberate cameras from the tripod and stand; hand-held cameras and spontaneous outdoor imagery.

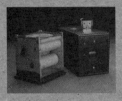

1885–1889
Technology
Eastman produces the first Kodak camera.

Culture
Peter Henry Emerson publishes *Life and Landscape on the Norfolk Broads*, the height of English 'naturalist' photography.

1890–1894
Technology
Thomas Edison's kinetoscope shows illusion of movement in rapidly presented sequence of individual images.

Culture
Jacob Riis's images reveal terrible conditions of New York tenement life in *How the Other Half Lives*. The Linked Ring, a London-based photographic brotherhood, seeks to promote photography as an art form.

1895–1899
Technology
The Kodak Brownie sells for $1. Wilhelm Röntgen discovers X-rays. Invention of Cathode Ray Tube (CRT) – the basis of television and computer displays.

Culture
Eugène Atget begins to photograph the people and sights of Paris in uniquely unsentimental style (his work is largely unnoticed until rediscovered by photographer Berenice Abbott in the 1920s).

1900–1904
Technology
First safety films from
cellulose acetate. Zeiss
introduces Tessar lens.
Single-lens reflex
cameras become
increasingly popular.

Culture
Alfred Stieglitz and the
Photo-Secession show
in New York.

1905–1909
Technology
First commercial
panchromatic plates.
First commercial colour
(Autochrome) plates.

Culture
Edward S Curtis begins
mammoth task to
photographically document
the American West and
Native American peoples.

1910–1914
Technology
Oskar Barnack develops
exposure test camera
for movie film. Louis
Dufay invents additive
colour photography.

Culture
Alvin Langdon Coburn,
a member of the
Photo-Secession, explores
abstract photography
with pinhole cameras
and later, mirrors.

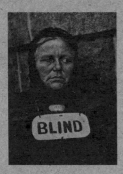

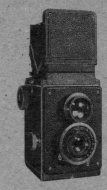

1915–1919
Technology
Kodak introduces subtractive two-colour Kodachrome.

Culture
Bauhaus founded in Weimar, Germany. Paul Strand's *Blind Woman* looks unflinchingly towards a new realism, leaving behind the pictorialist approach.

1920–1924
Technology
First transmission of pictures by wire. Barnack's O series Leica manufactured.

Culture
Man Ray's first rayograms (photograms). Photomontage work shown at first German Dada exhibition.

1925–1929
Technology
Rollieflex twin-lens reflex (TLR) camera introduced.

Culture
Albert Renger-Patzsch publishes *The World is Beautiful*.

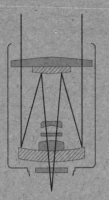

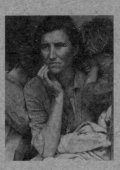

1930–1934
Technology
First mirror lenses (catadioptric). Weston Universal introduces first popular photoelectric light meter. Flash bulbs allow pictures to be taken anywhere.

Culture
Group f/64, dedicated to straight photography, is formed by Ansel Adams with Edward Weston, Imogen Cunningham and others.

1935–1939
Technology
Leopold Mannes and Leopold Godowsky perfect three-colour separation with separate emulsion layers in complex film that becomes Kodachrome. Kodak Super Six-20 automatic aperture setting (mechanical). Electronic flash in use. Cardboard mounts for slides.

Culture
Dorothea Lange's *Migrant Mother*, part of Farm Security Administration work, is published in *Midweek Pictorial*. Robert Capa's *Death of a Loyalist Soldier* said to depict moment of death. Walker Evans's first show forms basis of book *American Photographs*.

1940–1944
Technology
Ilford launches Multigrade variable-contrast paper. Diffusion image transfer discovered independently at Agfa and Gaevaert leads to document copiers and instant photography. Kodak introduces Kodacolor colour negative material.

Culture
Capa's iconic D-day landing photograph. Lee Miller, one of the few women war photographers, accompanies first allied soldiers into Nazi concentration camps. Yousuf Karsh takes his famously defiant portrait of Winston Churchill.

1945–1949
Technology
First successful self-developing camera system, Model 95, is marketed by Polaroid. Zeiss Contax SLR with pentaprism for eye-level viewing of unreversed image. Kodak launches Ektachrome colour reversal material.

Culture
Magnum photo agency founded by Henri Cartier-Bresson, David Seymour and Robert Capa. W Eugene Smith's photo essay *Country Doctor* is published in *Life*.

1950–1954
Technology
Plain paper copies from Haloid-Xerox xerographic camera. First incident light meter with dome diffuser.

Culture
Cartier-Bresson's book *Images à la Sauvette* (Images on the Run) is published in English translation as *The Decisive Moment*.

1955–1959
Technology
Nikon F. introduced. Resin-coated (RC) papers introduced. First zoom lens for amateur SLR camera introduced on Voigtländer Bessamatic.

Culture
Minor White founds *Aperture* magazine. Steichen curates *Family of Man* at MoMA, NY. Robert Frank's *The Americans* published in US with essay by Jack Kerouac.

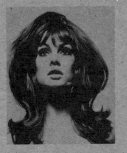

1960–1964
Technology
First colour 'instant' film
(Polacolor) sold by Polaroid.
Kodak launches Instamatic
cassette loading camera.
Cibachrome 'prints from
slides' process introduced.

Culture
John Szarkowski curates
The Photographer's Eye at
MoMA, NY. Andy Warhol
sets up The Factory. David
Bailey, Brian Duffy and
Terence Donovan become
celebrities in their own right
as fashion photographers on
the swinging London scene.

1965–1969
Technology
First colour photocopier.
CCD photocell invented at
Bell Labs (basis of digital
photography).

Culture
Nathan Lyons curates
*Towards a Social
Landscape* featuring work
by Bruce Davidson, Lee
Friedlander, Garry
Winogrand and Duane
Michals. Cornell Capa
founds International Fund
for Concerned Photography.
Images begin to define the
era, such as the Kennedy
assassinations, and the
moon landing. Eddie
Adams's image of street
execution of Viet Cong
prisoner wins the
Pulitzer Prize.

1970–1974
Technology
Integral colour image
transfer: the Polaroid SX-70.

Culture
Bernd and Hilla Becher
show their typologies of
industrial buildings in
influential exhibitions with
conceptual artists in Europe
and the US. Posthumous
exhibition of Diane Arbus's
work at Venice Biennale.

1975–1979
Technology
First digital images taken
by Steve Sasson at Kodak:
black-and-white image
recorded on to
cassette tape.
First selectable shutter,
or aperture-priority auto
exposure, camera from
Minolta. Canon Sure Shot
camera with IR rangefinding.

Culture
William Eggleston's is the
first solo show of colour
photographs at MoMA.
Susan Sontag's *On
Photography* is published
(1977). Cindy Sherman
produces her *Untitled
Film Stills*.

1980–1984
Technology
Kodak introduces
commercially disastrous
Disk format film and
cameras. Tabular-grain
films on sale.

Culture
Roland Barthes publishes
his influential book *Camera
Lucida* (1980). Second era
of celebrity photographers
such as David Lachapelle
and Mario Testino.
Postmodernism takes hold.

1985–1989
Technology
Minolta sells world's first
autofocus SLR system.
Fuji sells first disposable
(single-use) cameras. Heat-
developed colour transfer
material produced.
Adobe Photoshop image-
editing software introduced.

Culture
Nan Goldin's *Ballad of
Sexual Dependency* and
Robert Mapplethorpe's
The Black Book probe the
boundaries of public
acceptability. First
exhibition of digital
photography at San
Francisco Cameraworks.

1990–1994
Technology
Fuji Velvia reversal film introduced.
Kodak DCS based on Nikon F3, the first digital SLR (1.3Mpx), sells for over US$30,000. Kodak introduces PhotoCD.

Culture
Martin Parr continues to take a sideways look at the idiosyncrasies of mass culture and consumerism in Britain and around the world.

1995–1999
Technology
APS format film introduced. Nikon D1 first professional-quality digital SLR to be designed from scratch.

Culture
The anonymous snapshot and 'found' photographs are now subject of many exhibitions and books. William Wegman's images of his Weimaraner dogs capture the public imagination.

2000–present
Technology
Kodak stops production of film cameras.
50Mpx professional digital cameras go on sale.

Culture
Wolfgang Tillmans is the first artist/photographer to win the UK's Turner Prize. Tate Modern recognises the central role that photography now plays in fine arts with its *Cruel and Tender* exhibition. Strong environmentalist influences in the images of Canadian photographer Edward Burtynsky parallel Andreas Gursky's dry look at consumer topics and Gregory Crewdson's elaborately constructed surreal photography sets.

Photography is a major cultural force. It draws
its strengths from deep roots in both the arts and
science. This book is intended to give clear and
precise definitions of the widest range of photographic
techniques, genres and concepts as well as being an
introduction to the history of and personalities behind
photography. Please look on it as a stepping-off point
from which to explore new techniques and as a source
of explanation of the unfamiliar.

I hope this book furthers your understanding and, in
doing so, sharpens your enthusiasm for not only viewing
photographs from all eras in books and galleries but
also creating your own imagery.

Thank you again to Luke Richards for modelling, to Bianca Collie who sat for the lighting images and to Monika Ueffinger for allowing me to include my portrait of her. Thanks also are due to Sandra Myers for the loan of equipment for photography at short notice and to Mrs Pat Nixon for the use of the Softar filters on page 232. Thanks to Chris Bennion of Johnsons Photopia Ltd for the loan of the Sekonic light meters featured throughout the book (http://www.sekonic.co.uk/). Thanks also to Tammie Malarich for contributing to and helping organise entries for alternative photographic processes. As ever, a special thank-you to my wife Alison who helped organise and source some of the images as well as taking some of the pictures for the dictionary. Jeff Schewe's article *10 years of Photoshop* in *PEI* magazine (February 2000) was helpful in clarifying events in Adobe Photoshop history!

Whilst this volume is by no means exhaustive, we have tried our best to include all those terms that are most commonly used in the realm of photography. If you feel that we have missed any entries then please do let us know by sending an email, marked Visual Dictionary Entries, to enquiries@avabooks.co.uk. Please include your name and address and if your entry makes it into an updated edition of the book then we'll send you a copy for free!

Picture Credits